A Much Recorded War

FREDERIC A. SHARF

ANNE NISHIMURA MORSE

SEBASTIAN DOBSON

A Much Recorded

mfa MFA PUBLICATIONS
a division of the
Museum of Fine Arts, Boston

War

The Russo-Japanese War
in History and Imagery

MFA Publications
a division of the Museum of Fine Arts, Boston
465 Huntington Avenue
Boston, Massachusetts 02115
www.mfa-publications.org

Published in conjunction with the exhibition "A Much Recorded War: The Russo-Japanese War in History and Imagery," organized by the Museum of Fine Arts, Boston, from July 1, 2005 to March 28, 2006.

For a complete listing of MFA Publications, please contact the publisher at the above address, or call 617-369-3438.

COVER AND PAGES I–V: Details of *Picture of Our Valorous Military Repulsing the Russian Cossack Cavalry on the Bank of the Yalu River* by Watanabe Nobukazu (1872–1944); see page 11.

MAP on page 85 by Kristin Caulfield based on *Stanford's Map of Eastern China, Japan, and Korea* (London: Edward Stanford, February 9, 1904).

All illustrations were photographed by the Photo Studios, Museum of Fine Arts, Boston, and copyright © 2005 by Museum of Fine Arts, Boston, except those published with permission on the following pages: 32, Courtesy Kozuka Kazuko, Saitama Prefecture; 33 and 51, Photographs by Nakagawa Tadaaki of Artec Studio 262, Kyoto, Courtesy Tanaka Yoku, Tokyo; 38 (left), Courtesy Museum of the Imperial Collections (Sannomaru Shōzōkan), Imperial Household Agency; 38 (right), Courtesy Tokyo National Museum; 39, Photograph by Shirono Seiji, Courtesy National Research Institute for Cultural Properties, Tokyo; 40 (left), 43, and 46, Courtesy Illustrated London News Picture Library; 59, Courtesy Sepia International, Inc. and the Alkazi Collection of Photography, New York.

All Japanese personal names appear in the text in traditional style, with family names preceding given names.

ISBN 0-87846-691-6 (hardcover)
ISBN 0-87846-692-4 (softcover)

Library of Congress Control Number: 2005926796

Edited by Emiko K. Usui with Sarah E. McGaughey
Designed by Misha Beletsky
Produced by Theresa McAweeney

Available through D.A.P. / Distributed Art Publishers
155 Sixth Avenue, 2nd floor
New York, New York 10013
Tel.: 212-627-1999 · Fax: 212-627-9484

FIRST EDITION

Printed on acid-free paper
Printed at Sawyer Printers, Inc.,
Charlestown, Massachusetts

Contents

FREDERIC A. SHARF

A Much Recorded War

War broke out between Russia and Japan in February 1904. The world had been expecting it, and watched eagerly as events unfolded. During the summer of 1905, a negotiated peace was effected largely through the efforts of U.S. president Theodore Roosevelt, and the Russo-Japanese War, which had taken place in neither Japan nor Russia, ended in the most unlikely place of all—Portsmouth, New Hampshire. This book, therefore, is published on the one hundredth anniversary of the Treaty of Portsmouth, signed on September 5, 1905.

No war in prior history had ever been observed as closely, or recorded in so many formats, as the war between Russia and Japan. Certainly in previous combat situations, field commanders and military attachés had sent back reports, journalists had written stories, and illustrators and photographers had created pictures, all of which might have been published in books, newspapers, and magazines. But with the Russo-Japanese War, written and pictorial accounts of the war were brought together and distributed on an unprecedented scale and speed. Technological advances came together with new market forces and tastes to produce a stream of consumer products devoted entirely to the conflict. Had it not been for the world wars which followed, the Russo-Japanese War would have remained the most recorded war in history.

Our aim here is to introduce a sampling of the many images that recorded the Russo-Japanese War. Much of the imagery was informative or celebratory, but the propagandistic undertone of the content cannot be overlooked. No matter the format, the pictures tended to reinforce the political bias of the country in which they were made, or to which they were directed. Historians might debate which side actually won in military terms, but there can be no argument that Japan won the war in terms of propaganda. Simply put, Japanese artists and publishers were able to command a worldwide public's attention in ways that their Russian counterparts never mastered. Domestically, the images they created also imbued the Japanese consciousness with a powerful sense of nationalistic pride that would spur Japan's soldiers onto other foreign battlefields long after the Treaty of Portsmouth was concluded.

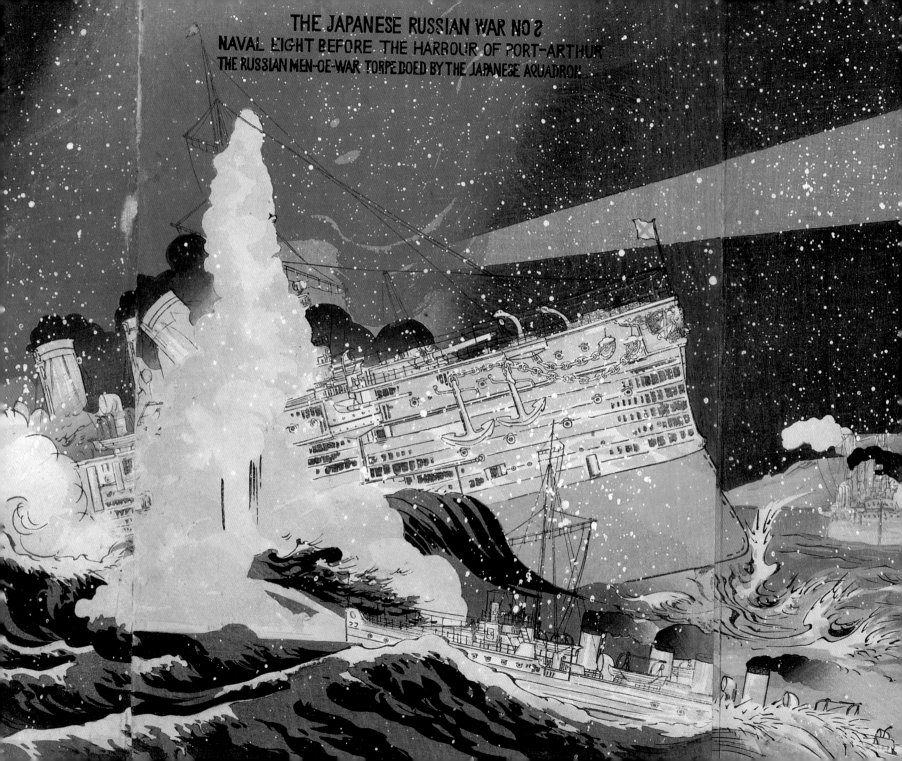

THE ORIGINS OF
THE RUSSO-JAPANESE WAR

To understand the war between Japan and
Russia, it is necessary to go back to the Sino-
Japanese War of 1894–95, in which Japan
and China fought for control over Korea and
Manchuria. The Japanese military defeated
the Chinese easily, and in April 1895 the two
countries agreed to peace terms that were
incorporated into the Treaty of Shimono-
seki. Japan received a large monetary in-
demnity, and China ceded to Japan Taiwan
(Formosa), the Pescadores Islands, and the
Liaodong Peninsula in Manchuria, on which
was located the strategic harbor of Port
Arthur (Lüshun). Korea remained an inde-
pendent but weak country that Japan
viewed as a quasi-protectorate.

As soon as these terms became known,
the ambassadors of Russia, Germany, and
France immediately protested to Japan's
Emperor Meiji. After some hasty considera-
tion, and as the three nations of the "Triple
Intervention" began to mobilize troops and
naval vessels, the Japanese government de-
cided to give back the Liaodong Peninsula.
The Japanese public and military leaders
were furious. Russia was the focus of their
desire for revenge because it had played the
leading role in demanding the retrocession.
Japan took the large cash indemnity from
China and invested it in a ten-year program

to rebuild its armed forces, especially the
navy. In the end, state-of-the-art war vessels
from British shipyards were the most visible
result of the Sino-Japanese War.

Though Japan was forced to relinquish a
foothold in China, other members of the
international community soon took
advantage of China's weakness to establish
their own bases there. Germany formed a
colony at Jiaozhou (Kiaochow) on the
Shandong Peninsula; England acquired a
lease on territory surrounding the city of
Weihai (Weihaiwei) on the nearby coast;
and Russia forced China into a lengthy lease
on the very same Liaodong Peninsula that
Japan had been required to abandon. These
territorial violations resulted in the rise of
an antiforeign movement within China that
erupted in the Boxer Rebellion of 1900.
From mid-June to mid-August, the foreign
legations at Beijing were besieged by angry
Chinese mobs. When the governments
of those embassies sent in troops to free
their citizens, Japan joined England, Russia,
Germany, and the United States in a
leadership role.

Most of the foreign troops began to go
home as hostilities ended in August, and by
September 1901 China had officially made
peace with all the nations affected by the
Rebellion. Russia, however, took advantage
of the upheaval in Beijing to initiate a
separate struggle for supremacy in

Manchuria. The Russians were motivated largely by the importance of their recently completed Trans-Siberian Railway, which linked Moscow in Europe with Vladivostok in Asia. Once the lease of the Liaodong Peninsula was executed, a branch line from Harbin down the Manchurian mainland to Port Arthur was also constructed. To protect these railway assets, Russia sent in thousands of "guards," in effect placing a sizable military force on Chinese soil.

This time, the international community, which had supported Russia in 1895 against Japan, refused to back its advances in China. Diplomatic pressure forced the conclusion of the Manchurian Convention of April 1902, under which Russia was to withdraw its troops in three stages: the first by October 8, 1902; the second by April 8, 1903; and the final one by October 8, 1903. Russia complied with the first stage of troop withdrawal, but then failed to do so for the second and third.

Russia's position was complicated. Most of all, its leaders wanted to protect the substantial investment in the Trans-Siberian Railway and the Manchurian connecting line; secondarily, because Czar Nicholas and some members of the Russian aristocracy had invested in timber concessions along the Yalu River, which separated Manchuria from Korea, they needed to protect those assets as well. In fact, it is likely that the czar

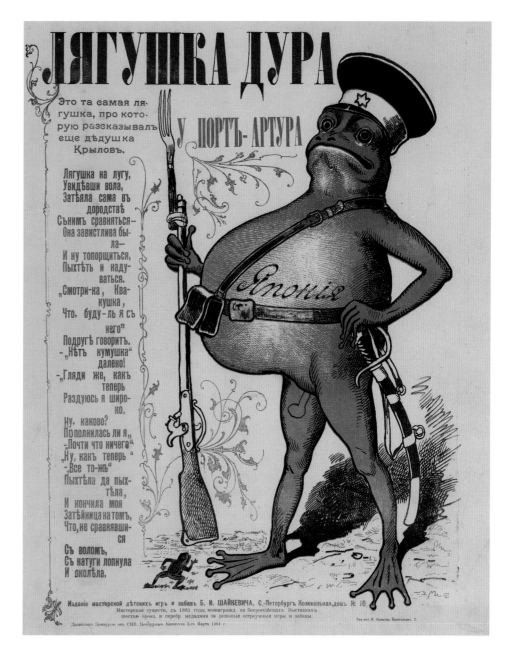

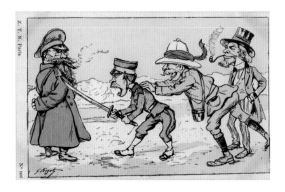

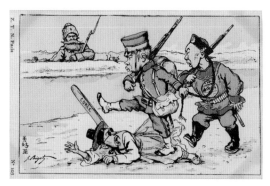

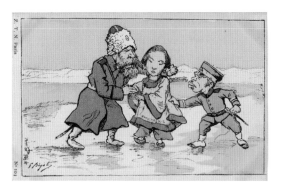

ABOVE
Georges Bigot (1860–1927)
Japanese Soldier Trying to Fight with a Russian
Soldier Urged on by an American and an Englishman
French postcard, 1904–05

ABOVE MIDDLE
Georges Bigot (1860–1927)
Chinese and Japanese Soldiers Trampling a Korean
Soldier
French postcard, 1904–05

ABOVE RIGHT
Georges Bigot (1860–1927)
Russian and Japanese Soldiers Scrambling for a
Chinese Woman
French postcard, 1904–05

himself canceled the further withdrawal of troops. The failure to withdraw in April 1903 was accompanied by the establishment of the Russian Lumber Company of the Far East, whose business it was to exploit the timber concessions and the construction of a fort at Yongampo (on the Korean side of the Yalu River) to protect them. Now, not only was Russia thumbing its nose at China, but it was also threatening Japan's domination of Korea.

By comparison, Japan's position in the spring of 1903 was quite simple. Russia was occupying Manchuria, when it had been Japan that had won it in the Sino-Japanese War. The Japanese also argued that the Russian timber concessions along the Yalu River threatened their primacy in Korea and made the peninsula a "dagger" pointed at Japan's very "heart." War was inevitable.

Other international developments gave Japan distinct advantages: In January 1902, it had entered into a formal alliance with England. In the United States there was great support for China to maintain its territorial integrity. The Americans, like the Japanese, did not want to see Russia in control of Manchuria and in fact were pressuring the Chinese to open new treaty ports there through which all nations could trade freely.

Attempts were made at diplomacy, but Russia insisted that Japan give up entirely in Manchuria, and Japan insisted that Russia give up entirely in Korea while also refusing any deals on Manchuria, so there was no common ground. Both governments, even while keeping up the pretext of negotiation, were making strategic decisions that pointed toward war. In August 1903, Czar Nicholas dismissed advisers who argued for caution and gave Admiral Eugene Ivanovitch Alexeiev the title of Viceroy of the Far East, stationing him in Port Arthur. In October 1903, Emperor Meiji moved his most brilliant military tactician, Baron

Kodama Gentaro, from his gubernatorial post in Taiwan, to be vice chief of the Army General Staff in Tokyo.

On October 8, 1903, the very day that the last Russian troops should have been leaving China, Viceroy Alexeiev staged a much publicized military review in Port Arthur. It seems clear that Russia did not take the threat of war with Japan seriously, under-estimating not only Japan's military strength but also, and even more important, the re-solve of the Japanese people. During the fall of 1903, Western observers in Japan com-mented on how solidly the Japanese public stood behind a possible war. On October 9, 1903, for example, Baroness d'Anethan, the wife of the Belgian ambassador to Japan, recorded in her diary:

Japan and Russia are on the eve of war. It is difficult to see how it can be averted. It does not look as though Russia, in spite of her promises, seems inclined to give up the occupation of Manchuria. . . . The Japanese are most bellicose. . . . Russia thinks [they] are playing a game of bluff, but there they are mistaken.[1]

As war between Russia and Japan loomed, the other major world powers looked on with great anticipation but did not intervene. China bared its diplomatic teeth and refused all of Russia's proposals for postponing the evacuation of Manchuria, but it could do little else. China's leaders felt deceived by their Russian tenants, and saw a Japanese victory as the only way to avoid a partition of their country among the greater world powers. As soon as fighting between Russian and Japanese troops began in Manchuria, China proclaimed all territory west of the Liao River to be neutral as a way to insulate the vast majority of the country from the war.

France had allied with Russia in a treaty of 1892, but because of concern that Russia was overreaching financially, France began to recommend peace. For its part, Russia had always looked to France for economic backing, so it felt confident in receiving monetary support for the war despite the lack of enthusiasm. In fact, in February 1904, 25 percent of France's international investments were in Russia. Germany, led by Kaiser Wilhelm II, who was related by marriage to Czar Nicholas II, favored the Russians and provided them with both financial and diplomatic assistance. The kaiser had always encouraged his "cousin" to look on Manchuria and eastern Asia as a logical boundary for the Russian Empire. It seems likely that the kaiser's real interest lay in building up his own navy while watching Russia entangled in a distant war.

Japan could count on the Anglo-Japanese Alliance of 1902 to put England in its camp; it also relied on the knowledge that Britain

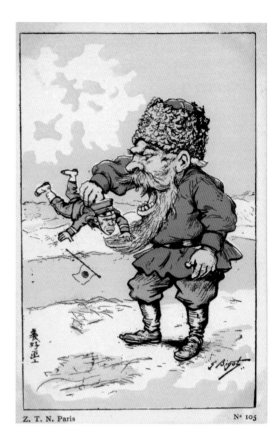

Z. T. N. Paris N° 105

Georges Bigot (1860–1927)
Giant Russian Soldier Holding a Japanese Soldier
French postcard, 1904–05

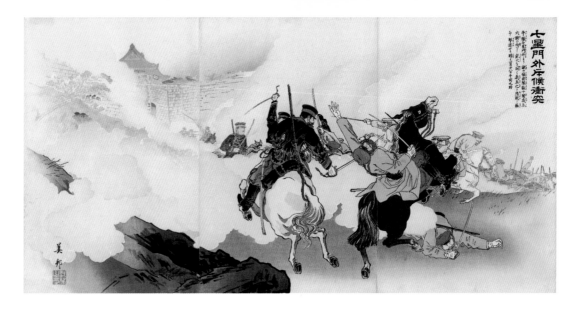

Yoshikuni (active 1904–1905)
Scouts Clash outside the Seven-Star Gate
Japanese woodblock print triptych, 1904

was worried about a potential Russian encroachment in Tibet, which insulated British interests in India. Japan was well aware that the United States did not want to see a powerful Russian presence in East Asia, and that the Americans had compelling reasons for keeping a close eye on the area: Hawaii and the Philippines were U.S. possessions by then; negotiations were being finalized for American construction of an interocean canal at Panama; and trade with China was seen as a historic American right.

Still, worried about U.S. support, the Japanese government sent Baron Kaneko Kentarō to New York City in February 1904. A Harvard graduate who knew Theodore Roosevelt from their college days, Kaneko was sent to influence the American president and to organize public relations in the United States for the Japanese cause. He interested Roosevelt in *bushido*, "the way of the warrior," and the martial art of jujitsu, even arranging for Roosevelt to obtain jujitsu instruction. From the very start of Kaneko's mission, the Japanese envisioned that Roosevelt would be the man to negotiate a peace. When war broke out, Roosevelt notified Germany and France that the United States would side with Japan if the Germans and the French sent troops to help Russia. His message kept Germany and France from actively participating in the war.

FIGHTING THE RUSSO-JAPANESE WAR

The lengthy period of uncertainty in 1903 created pressure within Japan to move

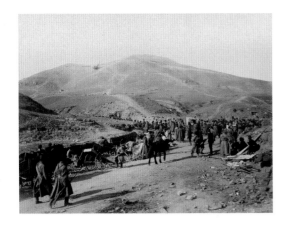

decisively in the New Year. The military establishment was of the unanimous opinion that a preemptive strike in January or February 1904 would provide the best chance of launching a successful war because Russia would be unable to move large numbers of troops from European Russia to Asia over the single-track Trans-Siberian Railway in the winter. Japan's armed forces were well prepared—the naval fleet was assembled at their base in Sasebo on the island of Kyūshū by the end of 1903, and ground troops were outfitted with warm clothing in preparation for a winter landing in Korea. When diplomatic efforts finally broke down on February 6, 1904, Japan was ready to strike.

Because Japan viewed control over Korea and Manchuria as the essential goal of military action, it is not surprising that on February 8 its leaders decided to strike si-multaneously in both places. The objectives in Korea—achieved within a single day—were to destroy the small Russian naval presence in the harbor at Inch'ŏn (Chemulpo), then to land troops and seize Seoul. In Manchuria, the Japanese navy was to incapacitate the Russian fleet at Port Arthur and establish itself at the mouth of the harbor and in the surrounding Yellow Sea. Such control would not merely mini-mize Russia's naval capabilities but also allow Japan to land troops along the Korean and Manchurian coasts. Although these objectives were not immediately achieved, a series of actions off Port Arthur over the next forty-five days ultimately provided Japan with naval command of the area.

Russian leaders were so completely taken by surprise by the twin attacks that ten days passed before they declared war. As Russia put a plan of action together, Japanese troops consolidated their hold on Korea. By mid-March the Japanese First Army, under General Kuroki Tametomo, successfully landed on the Korean coast at Nampŏ (Chinnampŏ) and quickly marched north to the Yalu River. When the Advanced Guard of the First Army occupied Uiju (Wiju) on the Yalu's southern bank on April 4, Korea was entirely under Japanese control.

During the first two months of the war, when Russia did not have a serious troop presence in Korea and its naval capabilities were bottled up by the Japanese fleet under Admiral Tōgō Heihachirō, there were only a series of small skirmishes on which to report. Nevertheless, the news media and its image makers were already in place, having anticipated the beginning of the conflict by several months, and they followed the events incident by incident. Printmakers in Tokyo even rushed into production with colorful depictions of imagined victories and presumed Japanese heroes.

By contrast, the month of April 1904 was

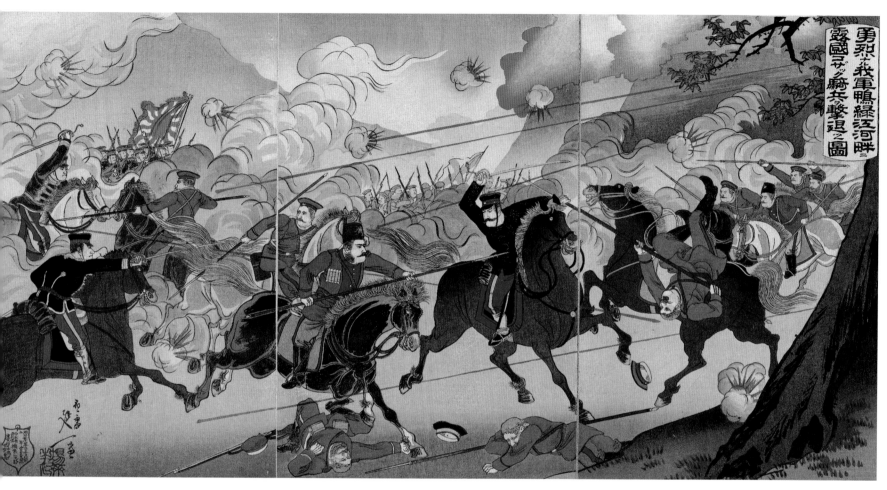

Watanabe Nobukazu (1872–1944)
Picture of Our Valorous Military Repulsing
the Russian Cossack Cavalry on the Bank of
the Yalu River
Japanese woodblock print triptych, March 15, 1904

Commander of the Manchurian Army. Field Marshal Marquis Ōyama.

THE ILLUSTRATION OF THE BATTLS OF JAPA AND RUSSIA. Nº45

consumed by a series of dramatic naval actions, which satisfied the desire of the Japanese and international news media for noteworthy—and image-worthy—stories. However, the real drama lay in the elaborate plans being prepared by the Japanese army for the invasion of Manchuria. On April 29, General Kuroki's First Army took control of Tiger Hill, on the north bank of the Yalu River, and within a day it had constructed a bridge across the water. On May 1, after the Manchurian city of Jiuliancheng (Kiuliencheng) was captured, the Imperial Highway to Liaoyang could be selected as the First Army's route of travel. Four days later, the Japanese Second Army, under General Oku Yasukata, landed in Manchuria at Pitsewo; and on May 19, the Japanese Fourth Army, under General Nozu Michi-tsura, was able to land at Takushan. By the end of the month sufficient numbers of troops had assembled in Manchuria to form the Japanese Third Army under General Nogi Maresuke, whose assignment would become the investment by land of Port Arthur.

Japan's strategy in Manchuria now concentrated on two objectives: the complete isolation of Port Arthur—on the ocean side by Tōgō's fleet and on the land side by Nogi's army—and the capture of the important commercial city of Liaoyang as a prelude to the ultimate capture of the

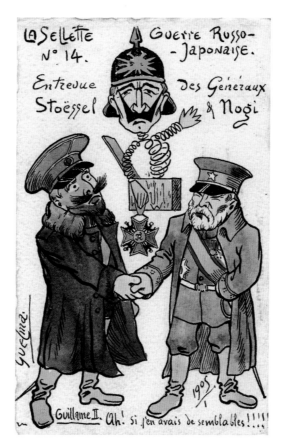

Signed "Guelma"
Interview of Generals Stoessel and Nogi
French postcard, 1905

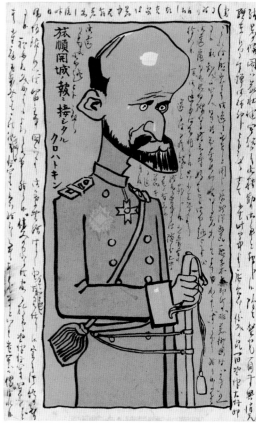

Artist unknown
General Kuropatkin Hearing the News of the Surrender of Port Arthur
Japanese postcard, canceled 1905

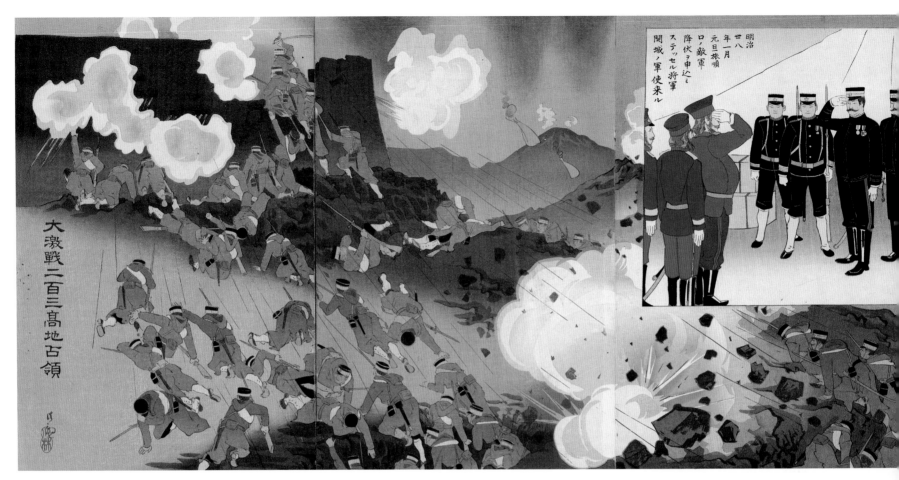

Kobayashi Kiyochika (1847–1915)
Severe Battle: Occupation of 203 Meter Hill
[near Port Arthur]
Japanese woodblock print triptych, 1905

capital, Mukden (Shenyang). Ironically, the Japanese armies could now make use of the peninsula's Russian-built railway line to move their troops north from Port Arthur.

For the balance of 1904, worldwide attention was focused on whether Japan would achieve these goals. The capture of Port Arthur had strategic importance, but even more, it held symbolic significance. In November 1894 Japan had captured Port Arthur during its war against China, only to lose it again in May 1895, largely through the machinations of Russian diplomacy. Now, after only five months of war with Russia, Japan was in a position to retake the jewel, and the man put in command of this effort was the same General Nogi who had led the successful Sino-Japanese War campaign.

The investment and siege of Port Arthur alone required six months of slow, bloody, and tedious effort that was costly not only in monetary terms but even more so in the loss of human lives on both sides. Because the entire process took place in a relatively confined geographic area, journalists were able to obtain numerous eyewitness accounts. By the time the city surrendered on January 1, 1905, the entire world was immersed in the day-to-day progress of the Japanese army.

The rest of the campaign provided the media with other dramatic engagements to

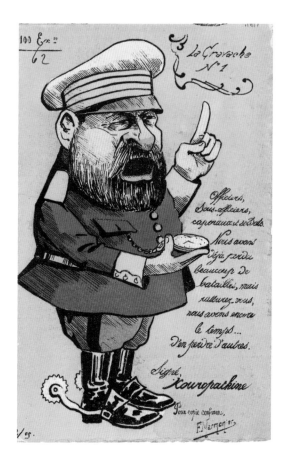

Signed "F. Marmonier"
General Kuropatkin
French postcard, 1904–05

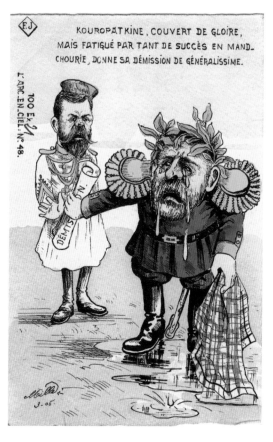

Signed "Mille"
Kuropatkin Covered with Glory
French postcard, 1905

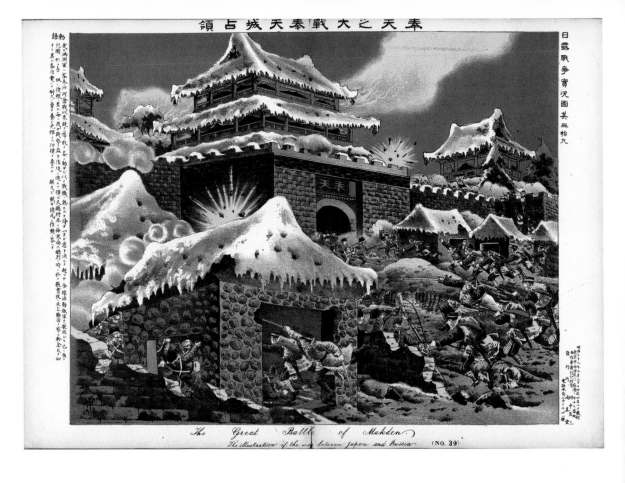

report. Large numbers of opposing troops were deployed in exotic settings, at first under the very harsh Manchurian summer heat, and later under the equally harsh winter cold. While General Nogi's Third Army encircled Port Arthur, the First Army moved through the Manchurian mountains along the Imperial Highway to Liaoyang, and the Second and Fourth Armies moved north on the Liaodong Peninsula toward the same goal. On July 6, Japan had decided, amid much ceremony in Tokyo, to send its two senior military commanders, Field Marshal Ōyama Iwao and General Kodama Gentaro, to take personal charge of the armies converging on Liaoyang.

Numerous local battles took place between the advancing Japanese and the retreating Russians, but world attention focused on the summer battle at Liaoyang,

which was fought over a seven-day period before the Russian army, under General Kuropatkin, abandoned the city in the early-morning hours of September 4. The Russians retreated in an orderly way to the Sha River, where the last battle of 1904 was fought in mid-October prior to both armies' settling into winter quarters on each of the river's banks. In January 1905, Russia tried unsuccessfully to mount offensives against the Japanese, but ultimately its forces retreated to Mukden, where the last important battle of the war was fought over a ten-day period in March. The two opposing armies consisted of more than five hundred thousand soldiers, making it the largest confrontation in world history until that time and in an ominous way forecasting the even larger ones fought on the Western Front during World War I.

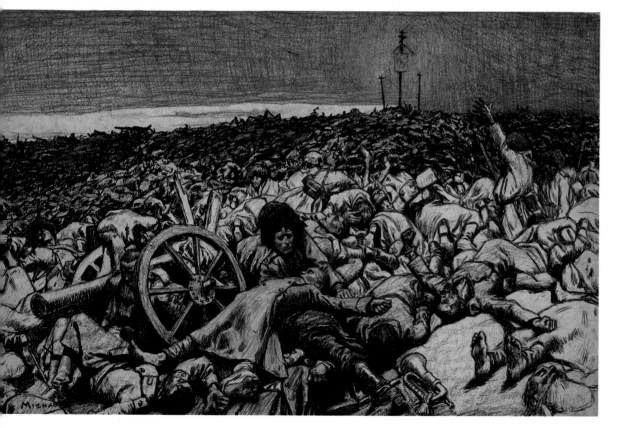

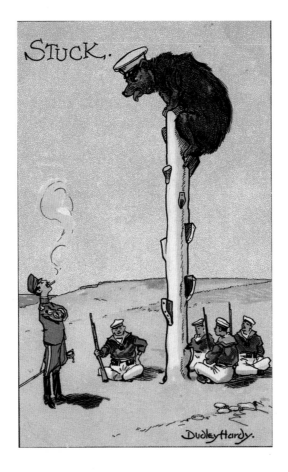

Dudley Hardy (1866–1922)
Stuck
English postcard, 1905

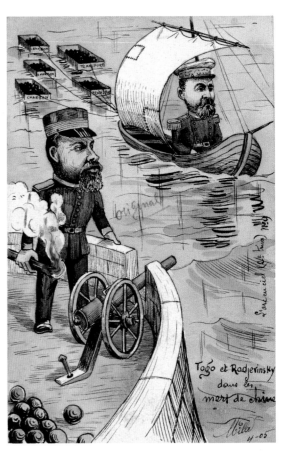

Signed "Mille"
Tōgō and Rozhdestvenskii in the China Seas
French postcard, 1905

The Russian army withdrew from Mukden during the second week of March. Although it had lost an unbroken string of battles, it would have been a mistake to assume it was defeated. In fact, with spring approaching and the near completion of improvements to the Trans-Siberian Railway, the Russians were in a good position to bring in fresh troops from their European army groups to take up the war. Although Japan was the apparent victor, it had exhausted its resources. Its lines of communications were stretched thin over the Battle of Mukden's one-hundred-mile front, its available manpower was limited, and its leaders were worried about continuing financial pressures. Moreover, the number of Japanese wounded or killed at Mukden was estimated to be as high as seventy-five thousand men, or 25 percent of the army. The huge losses were never communicated in precise numbers to the Japanese public, but the figures persuaded the government, as much as anything else, to look toward ending the war.

The Japanese victory at Mukden almost immediately set off a push for peace by other countries as well. France was over-

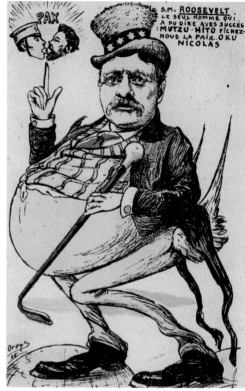

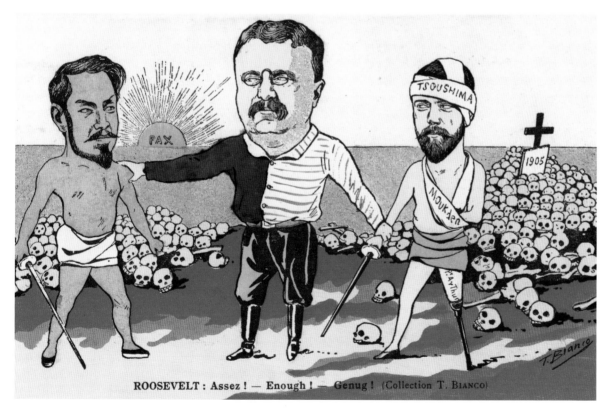

ROOSEVELT: Assez! — Enough! — Genug! (Collection T. Bianco)

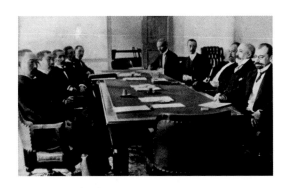

Photographer unknown
The Russian and Japanese Delegations in the
Meeting Room, Building 86, Portsmouth Shipyard
American photograph, August 8, 1905

extended in Russian loans; Germany was fearful that Russian instability would result in the export of revolutionaries; and England and the United States knew that Japan was stretched thin in terms of both men and money. On April 5, 1905, the French made the first move by offering to mediate a settlement, but the Japanese rejected them at once.

The peace initiative was set back not only by the perceived inappropriateness of France as a mediator but also by the feeling on both the Russian and the Japanese side that unfinished military business remained. Russia hoped to bring seasoned troops to the front, and Japan sought an important naval victory over the large Russian fleet, which was known to be heading to the area. The Baltic Fleet had left their base in the Gulf of Finland on October 15, 1904, and was scheduled to reach the Manchurian coast sometime in May 1905. Their lengthy voyage had been extensively covered in the news media, and their ultimate destination was known to be Vladivostok. What was unknown was exactly how they would reach the Russian seaport without engaging the Japanese fleet under Admiral Tōgō.

The combination of Russian reinforcements coming over the railway and a substantial Russian fleet arriving at Vladivostok could change the military dynamics of the war. Japan correctly regarded the defeat of

the Baltic Fleet as critical. The ultimate battle, known as either the Battle of the Japan Sea or the Battle of Tsushima, opened on May 27 and concluded on the following day with the Baltic Fleet's total destruction.

Now fulfilled in its military objectives, Japan secretly notified President Roosevelt on May 31, 1905, of its willingness to negotiate a peace settlement. Czar Nicholas conveyed his equally secret willingness to him on June 6. With such a nod from each party, Roosevelt could publicly make himself available as mediator, which he did on June 8. Japan announced its willingness to cooperate on June 10, and Russia did likewise on June 14.

Both countries then selected their delegates, announced on July 2, and assembled them on August 8 in Portsmouth, New Hampshire, for the peace conference. Portsmouth was chosen because Washington, D.C., was too hot, and Newport, Rhode Island, too sociable. Further, Portsmouth had a navy base on which to hold the meetings and convenient first-class hotel accommodations on the New Hampshire coast.

Japanese public opinion, which had been shaped by its own media and image makers, viewed Japan as the winner of the war. Thus, the Japanese people expected that Russia would pay a sizable monetary

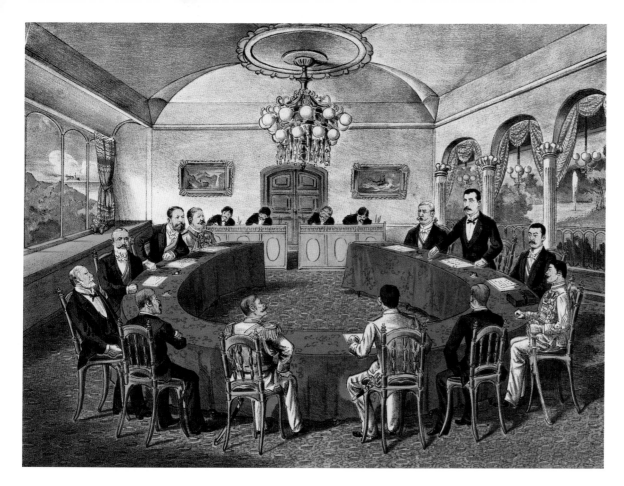

Artist unknown
Negotiating Peace, Portsmouth, America
Japanese lithograph, August 1905

indemnity as China had done in 1895, and that it would agree to substantial territorial concessions, the least of which would be the island of Sakhalin. Although world public opinion, until the time of the peace conference, had also crowned Japan the winner, Japan's government advisers knew that the time had come to exit the war. When the twenty days of conference deliberations ended on August 29 and the Treaty of Portsmouth was signed on September 5, Japan had settled for no indemnity and only half of Sakhalin Island.

The Japanese press learned of the approved terms of the treaty on August 30, 1905, and within a few days proclaimed them a national humiliation. On the day of the treaty's signing, Tokyo was engulfed in riots. Martial law had to be declared and was not lifted for nearly a month.

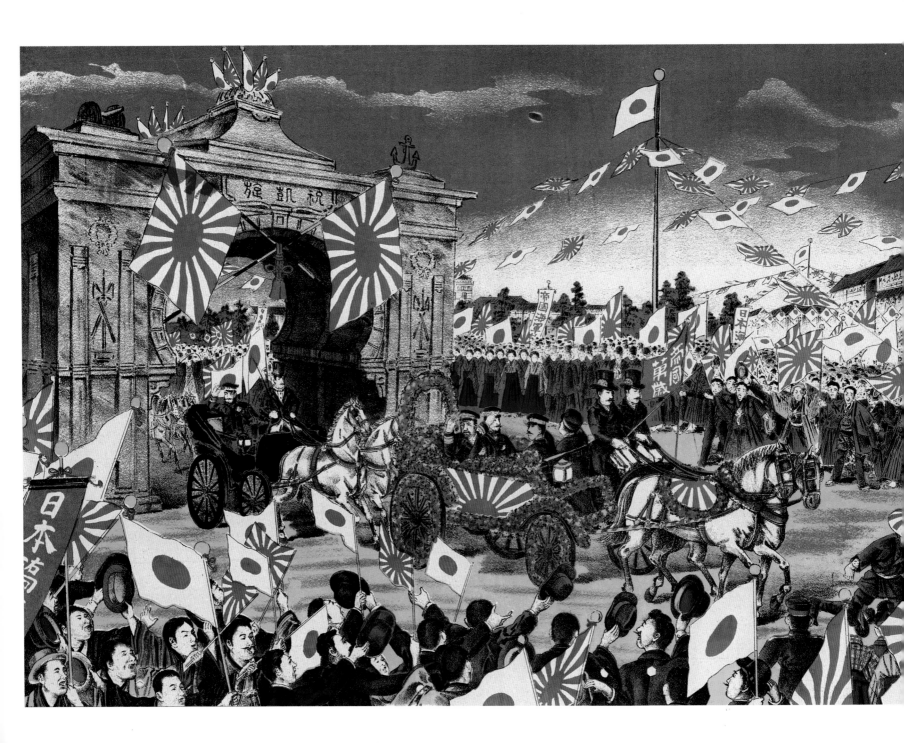

Ultimately, however, the Japanese public accepted the terms and welcomed back its heroes in a series of elaborate public celebrations that extended until the end of April 1906.

Japan had certainly won the naval and military aspects of the war; in fact, its triumph was so spectacular that the country leapfrogged onto the world stage as a major power. It won control over Korea (which in 1910 became a Japanese colonial possession), a significant portion of the railway line down the Liaodong Peninsula (which effectively secured Japan's hold on the commercial life of Manchuria), both Port Arthur (important for military purposes) and Dalian (Dalny, a commercial harbor), and, last but not least, the southern half of Sakhalin.

Russia walked away without having to pay an indemnity, and without losing Russian territory. Sakhalin Island was controlled entirely by the Japanese by the time of the peace conference, so Russia was glad to retain half of it in the negotiations. It had to give up the railroad from Changchun to Dalian and Port Arthur, but that was better than having to relinquish it as far north as Harbin as the Japanese had demanded when peace negotiations began. Finally, in spite of an unbroken series of military defeats, Russia's overall strength had not been compromised.

Although the war ended in the summer of 1905, worldwide interest did not subside until it was superseded by the outbreak of World War I in the summer of 1914. Historians pondered the meaning of events; military observers traveled to the battle sites with hopes of deriving useful tactical lessons; and Western nations that had applauded Japan during the war became increasingly fearful of its newfound power.

REPORTING
THE RUSSO-JAPANESE WAR

Although now a neglected, if not forgotten, event overshadowed by other international conflicts, in its own time the Russo-Japanese War attracted hundreds of foreign observers and dominated the international media. Even before the war began, commanders of the major powers' armed forces were anxious to get competent attachés in position to travel with the opposing armies, and the news media similarly scrambled to send experienced foreign correspondents to report on anticipated battles, as well as special human-interest stories. Other informed foreigners who watched the war included doctors and nurses sent to study medical practices on both sides.

Military and naval attachés were chosen by their respective war departments, often on very short notice, and then dispatched

to their embassy in either Tokyo or Saint Petersburg. Upon arrival, they would be sent to the Japanese or Russian war department to obtain the necessary credentials, where they would often be subject to infuriating delays.

An army attaché required extensive support systems—an orderly, a servant, horses for all three, a cart drawn by an additional two horses with equipment and provisions—and usually traveled in a group with an interpreter. A naval attaché had fewer needs on a ship, and so could travel with much less. All attachés were expected to keep detailed notes and to file written reports upon completion of their tours of duty. These reports not only contained extensive coverage of events but, more important, outlined with great precision the equipment, facilities, and fortifications along the way—invaluable firsthand information to the state departments of the various Western powers. Many attachés also proved to be keen observers of the people they encountered, whether they were Japanese or Russian soldiers or Chinese civilians. Their reports also depicted the scenery and countryside through which they traveled.

Attachés from countries sympathetic to the side they were observing were allowed to see more and so were more effective. Thus the British were afforded the most access to the Japanese army and navy because of the Anglo-Japanese Alliance; French and German attachés were the best received by the Russians. Americans were well received by the Japanese, but not by the Russians. A large number of attachés visited the battlefronts, but not all were there at once—perhaps 50 percent of those credentialed were allowed to be present at any given time. Some attachés remained on the job for the entire war, and others left after only a few months of duty.

Although no one could accurately forecast when newsworthy events would occur, it was clear that some time would be required to put observers in place. Given the rigors of travel by rail and ocean liner, plus the unavoidable bureaucratic delays, it was safe to assume that observers traveling to either side would need no fewer than thirty days to get in position, or sixty days if they were going to the battlefront. A typical journey from London to Japan, for example, would involve a steamship over the Atlantic, then a train across the North American continent to Vancouver or San Francisco, and then another boat over the Pacific, usually to Yokohama. If connections could not be made or if permits were not issued in a timely fashion, days or even weeks of waiting could be added to one's journey.

Making a transcontinental journey over Europe and Asia to get to the Russian side was even more difficult than traveling to

George Soper (1870–1942)
The Russian Debacle
English illustration, 1905

Japan. It took U.S. navy lieutenant commander Newton A. McCully, for example, more than two months to get from his post in Washington, D.C., to the Russian front line at Liaoyang. His trip involved taking a train from the capital to New York, a Cunard ocean liner to Liverpool, another train to London and then a long wait of two weeks before receiving papers to travel by another train to Saint Petersburg, then yet another for Moscow to catch the Trans-Siberian Railway for Harbin in Manchuria, another connection to Mukden, and, finally, the last leg of his trip, which took twelve hours to travel the fifty miles to Liaoyang. The challenges of reaching the Russian front would then be equaled by those of getting information back to Europe and the United States; written reports, photographs, and sketches needed to pass through censors and travel back via the same tortuous routes that the men had taken to get there.

Journalists encountered the same travel conditions and similar delays in obtaining permits and passes. A few British journalists left for Asia as early as the spring of 1903 but

quickly realized their trip was premature. The next group departed from Europe or the United States in the fall of 1903, and though they also arrived too soon, they simply stayed on until events developed; thus they were on hand to provide international audiences with the earliest eyewitness accounts of the war.

Among the first English-speaking reporters to arrive—and one of the foremost war correspondents in the world at that time—was Bennet Burleigh of the *Daily Telegraph* (London). Having been sent from Liverpool in mid-October 1903 via New York and Vancouver, he arrived in Yokohama at the end of November. Disappointed to find no visible signs there of the impending war, he went on to Manchuria, which he (correctly) assumed would be the location of any ultimate conflict. While crossing the Yellow Sea, he saw Japanese battleships painted in black—the color used for battle. On a train from Dalian to Port Arthur, he met with fellow British newsman Francis McCullagh, who had been hired by *Novi Krai*, the Russian newspaper in Port Arthur, to start an English edition. The Russians knew as well as the Japanese how important it was to reach the English-speaking world with their side of the unfolding story. After visiting with McCullagh, Burleigh took a seventeen-hour train ride north for Mukden, after which he came back to Port

Arthur for one week and then returned to Japan. A *Japan Weekly Chronicle* reporter claimed on December 23, 1903 to have met him in Kobe on that day: "We understand that Mr. Burleigh goes to Tokyo with the object of being on the spot when the first movement is made by Japan."

Burleigh was among seventy diners in Tokyo on the evening of January 15, 1904, at an elegant banquet hosted by Sonoda Kōkichi, president of Noble's Bank. The other guests included members of the Japanese press, officials of the navy and army, major business executives, and, most important, British and American military observers who had already arrived for the as-yet-undeclared war, as well as British and American journalists. Aside from Burleigh, E. J. Harrison of the *Daily Mail* (London), Martin Eagen of the Associated Press, Arthur M. Knapp of the *Boston Evening Transcript*, and Frank Brinkley of the *Times* (London) were among the foreign reporters present. According to the January 23 edition of the *Japan Weekly Mail*, Sonoda thanked the group "for their support of Japan at this critical time." Japan, he said, was fortunate to "have England as our ally . . . and the United States as our best national friend."

As the month of January 1904 progressed, the influx of important war correspondents to Japan grew, and even in February, as war was erupting, trans-Pacific steamships

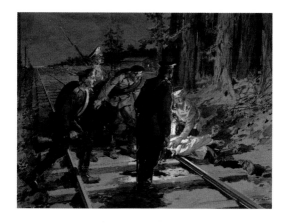

Frederic De Haenen (active 1896–1920)
End of a Deserter: A Tragedy on the Trans-Siberian Railway
English illustration, February 11, 1905

continued to bring members of the foreign press—reporters, illustrators, and photographers—to Yokohama each week. Some of them even brought their wives. Once war was officially declared and real fighting began, the stream of newsmen became a river, and by the middle of March they formed a virtual army of their own. Once in Japan, however, they were subjected to the strict censorship with which the Japanese authorities clamped down on all military news and to the arduous process of obtaining the necessary permits to be able to witness, and thereby report, anything of significance. After actual fighting began, access to the front in particular was extremely limited.

Of all the visitors to Japan hoping to gain firsthand war exposure, the journalists were the most frustrated, or at least the most vocal in expressing their unhappiness over being cooped up in Tokyo. These men had covered wars in countries all over the world and had never been prevented from reaching the front lines. Ever mindful of a potential public relations disaster, Baron Hachiroemon Mitsui entertained the first group of men on February 21, 1904, at his exclusive Mitsui Club, where he outlined an idea that he offered to bankroll—a publication for which each correspondent would write a brief account of one memorable war experience, with the proceeds from the sale to benefit soldiers and their families. Ultimately, forty-nine correspondents contributed their accounts to *In Many Wars*, edited by George Lynch and Frederick Palmer, and with a preface datelined May 8, 1904, at the Imperial Hotel in Tokyo. There is no record as to how many copies were printed or sold, but Melton Prior, one of the contributors, estimated that thousands of pounds would be raised by the sale of this publication.

A group of sixteen foreign correspondents (of whom eight were British, six American, one French, and one German) finally received permission in early April to accompany General Kuroki's First Army in Korea. A comparable number of foreign military attachés from several countries received permission at the end of the month. A second group of war correspondents left Tokyo on July 18 to join General Oku's Second Army, and a final group left on July 30 to join General Nogi's Third Army. Their dispersal allowed for some eyewitness accounts to be reported to Europe and the United States from the various battlefronts, but it did not mean that any of these men would be allowed to go close to soldiers in action. The extant photographs and illustrations by the correspondents and attachés in these groups indicate that they were taken or drawn while the men were standing on hills far from the battle; these

views were as much of the war as any of them were allowed to witness.

The coverage originating on the Japanese side made a much larger impression on worldwide public opinion due, to a large extent, to the enthusiasm and diligence of the news media within Japan rather than that of the foreign press. After Japan's victory over China in 1895, the domestic press had grown—by the time of the Russo-Japanese War, not only was there a greater number of newspapers and magazines, but their combined circulation had vastly increased. They had also become aggressive in their coverage of current events and powerfully nationalistic in tone. Moreover, both editors and government censors were well aware that news stories and their accompanying images, though intended primarily for the Japanese public, would often be picked up by the foreign media and relayed to international audiences. Many domestic wartime publications therefore provided convenient synopses and captions in English alongside those in Japanese.

Most Japanese newspapers were ready to send correspondents, as well as artists and even photographers, as soon as war was declared, for they had been in place and preparing for the conflict for much of 1903. In addition, special publications devoted to the war were quickly established. One of the first to get organized, *Senji gahō* (Wartime Pictorial), managed to have its inaugural edition out on February 21, 1904, followed by regular editions three times each month until October 1, 1905. The proprietors of this magazine had been in business with an illustrated monthly publication on current events entitled *Kinji gahō* (Contemporary Pictorial). After the outbreak of war, they quickly realized that "current events" would now mean "war coverage," so they abandoned their original title and devoted the revised periodical to the war. The new magazine reached a considerable domestic market with a first volume print run of fifty thousand copies. The first three issues were published entirely in Japanese, and then, beginning with the fourth (on March 20, 1904), the magazine also carried an English title, the *Japanese Graphic*, and English captions to all illustrations.

The sources for *Senji gahō*'s images were primarily Japanese. Its editors (the head of whom was the well-known Meiji novelist Kunikida Doppō) sent writers, artists, and photographers to the front and boasted that within a few weeks they had sixty photographers under signed agreements to provide candid photographs. They also had an organized group of Tokyo-based studio artists who could produce Western-style illustrations of all war incidents, and they paid for independent photos and drawings sent unsolicited to their offices. The

Albert Edward Jackson (1873–1952)
A Lonely Japanese Vigil, *cover image for* Japan's Fight for Freedom, *volume 45* *English illustration, 1905*

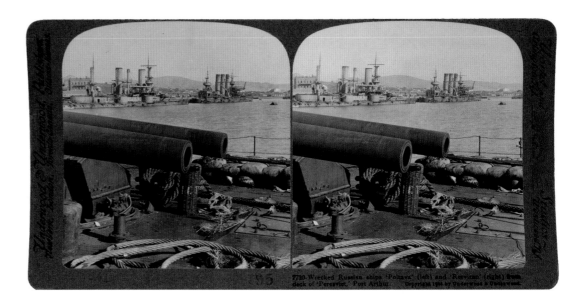

James A. Ricalton (1844–1929)
Wrecked Russian Ships *Poltava* and *Retvizan* from
Deck of *Peresviet*, Port Arthur
Published by Underwood & Underwood
American photographic stereocard, published 1905

content of *Senji gahō* also reveals a cross-
"borrowing" of images with the *Illustrated
London News* and *London Graphic*.

As fighting progressed, *Senji gahō* assigned
front-line illustrators to each Japanese
army, engaged a special artist to travel with
Admiral Tōgō on the *Mikasa* for its entire
tour of duty, and sent reinforcements to
accompany artists already in place for the
Liaoyang and Mukden campaigns. Special
combat victories, such as those at Liaoyang,
Port Arthur, and Tsushima, required special
issues, as did such subjects as Russian prison
camps within Japan and the visits of foreign
celebrities.

Several larger Tokyo companies also
jumped into wartime publishing. One such

organization was Hakubunkan, which had
been founded in 1890 and published a vari-
ety of magazines and books, and which even
had a subsidiary to supply paper to printing
companies in Tokyo. Among its most suc-
cessful war periodicals was *Nichiro sensō
shashin gahō* (The Russo-Japanese War Pho-
tographic Pictorial), which promoted itself
as a magazine of photographs, but also made
use of a prestigious group of Tokyo artists,
such as Kubota Kinsen (1875–1954), Naka-
mura Fusetsu (1866–1943), Odake Kokkan
(1880–1945), Tōjō Shōtarō (1865–1929), and
Watanabe Shin'ya (1875–1950). These
painters and printmakers created internal il-
lustrations that were published in black and
white, as well as full-color lithographs to be

inserted as frontispieces with English titles. Like the competitor's *Senji gahō*, most of the Hakubunkan journal was in Japanese, but all illustrations had English captions as well.

The publishing company that most directed its products to the English-speaking market was Kinkōdō, which, in association with the Tokyo bookseller Maruzen, began producing a series of handsome war publications in April 1904. The ten volumes of its flagship title, *The Russo-Japan War Fully Illustrated*, were published entirely in English from April 21, 1904, until October 25, 1905. This magazine carried news stories and full-color lithographs by established Japanese artists and remains a useful source of information on the war.

Kinkōdō quickly realized that there was a potential market for other foreign-language publications, so in April 1904 it produced its *Manual of Conversation*. With phrases in English, Japanese, Russian, and German, it targeted the influx of visitors to wartime Japan. In the same month, it announced the first of six bilingual—English and Japanese—volumes in a horizontal, hardcover, photo album format that combined numerous Western-style illustrations with some photography. For this series, it ran a contest at the Tokyo Fine Art School, with cash prizes offered for "the most spirited war pictures." After the Battle of the Japan Sea (Tsushima), on

August 25, 1905, Kinkōdō also quickly came out with a biography of Admiral Tōgō, by the popular English missionary and teacher Arthur Lloyd.

Many observers at the time regarded the war as a gigantic public relations contest, and to a great extent it was with wartime publications such as these that Japan won that contest. Through them, it convinced the world that its interests in Korea and Manchuria were threatened, and it succeeded in gaining international support for its cause. Japan selectively permitted coverage of the war, and then exercised considerable control over the resulting stories and images.

There can be little doubt that Japan emerged from the war as a world power in terms of both military might and the ability to shape international diplomatic and public opinion. While the Russians would grow deeply divided and head toward internal revolt, the Japanese rapidly rebuilt Port Arthur and Dalian, and transformed the railroad inherited from the Russians into one of the world's best-run transport systems. Throughout Manchuria they modernized other towns and cities, built factories, and developed agriculture. Exports from the territories under Japan's control flourished. Embedded in all this success, however, were the seeds that would ultimately grow into World War II.

NOTES

1. Baroness Albert d'Anethan, *Fourteen Years of Diplomatic Life in Japan,* 2nd ed. (London: Stanley Paul, 1912), 341.

ANNE NISHIMURA MORSE

Exploiting a New Visuality

The Origins of Russo-Japanese War Imagery

Artist unknown
Robe with dyed design of the surrender of General Stoessel
to General Nogi
Japanese omiyamairi *robe, about 1905*

OPPOSITE
Artist unknown
Textile printed with design of Russo-Japanese War
military leaders
Japanese nagajuban *textile (detail), about 1905*

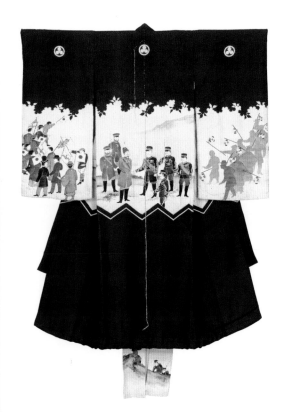

Just prior to his death in 1904, Lafcadio Hearn described in vivid detail the proliferation of visual imagery that accompanied the first victories of the Japanese forces in the Russo-Japanese War. Best known for his romanticized accounts of Japan and his retellings of traditional ghost stories, the Anglo-Greek expatriate, who resided in Japan for almost fifteen years, wrote: "Even silk dresses for baby girls had charming ornamentation composed entirely of war pictures, or rather fragments of pictures, blended into one astonishing combination: naval battles, burning warships, submarine mines exploding; torpedo boats attacking; charges of Cossacks repulsed by Japanese infantry. . . . Here were colors of blood and fire, tints of morning haze and evening glow."[1] Indeed, during the Russo-Japanese War, which lasted little more than twenty months from February 1904 to September 1905, combs, fans, cakes, signboards, lanterns, dress materials, towels, toys, miniature gardens, and prints were all used to promote Japan's military prowess by incorporating designs of scenes of the front, heroic servicemen, and images of battleships and artillery.

The effective dissemination of visual propaganda was critical for the Japanese in mobilizing international and domestic support during the Russo-Japanese War. Closely watched by the West, which harbored many fears of the "Yellow Peril," and aware of the sacrifices that would be required by the nation in confronting the great Russian Empire, the Japanese government was aggressive both abroad and at home in its promotion of itself as a modernized nation that should rightfully be accorded the respect of the international community. Crucial to these efforts was the exploitation of imagery—much of which had been developed ten years earlier during the Sino-Japanese War (1894–95)—to proclaim Japan's worldly ambitions. Indeed, Lafcadio Hearn had recorded in his 1896 "insider's account" of Japan, *Kokoro*, that during the Sino-Japanese War, "men at once set to work writing histories of the triumphs of Japan," which were "issued to subscribers in weekly or monthly parts, and illustrated with photolithographs or drawings on wood."[2] At that time, as well, toy makers, porcelain makers, and metalworkers had integrated images of the

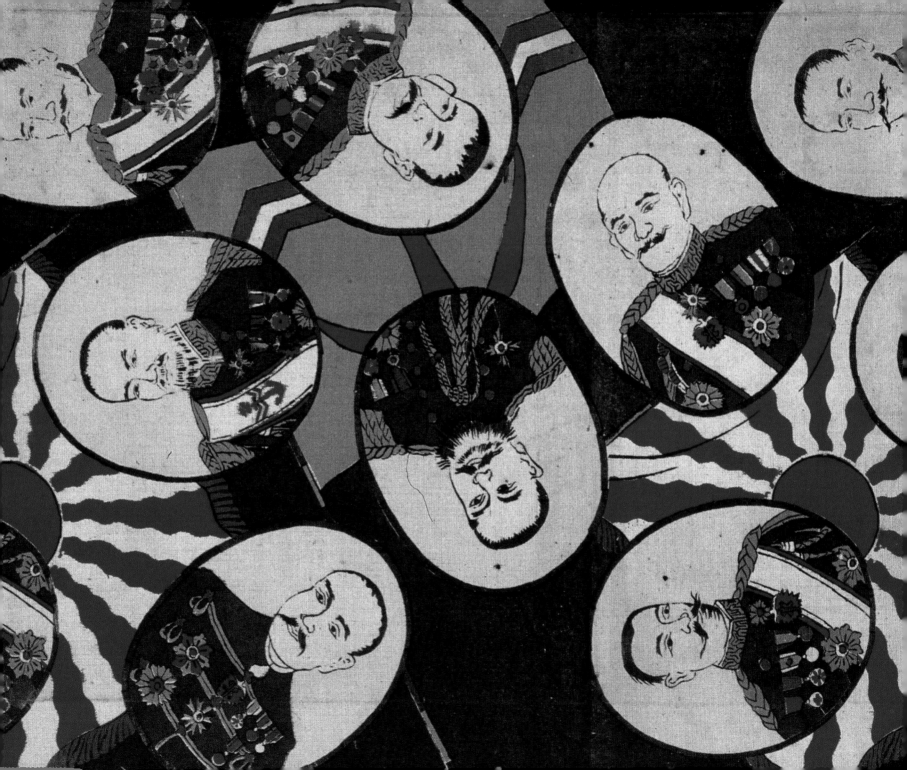

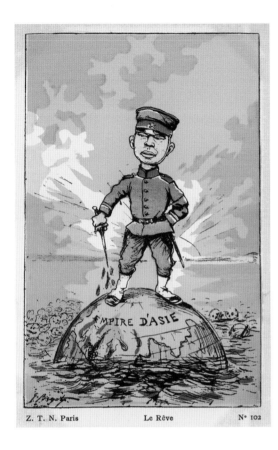

Georges Bigot (1860–1927)
Empire of Asia
French postcard, 1904–05

victories and "incidents of sacrificial heroism" into their work.

During the Sino-Japanese War, Japan had moved against its neighbors and European colonial interests to assert its own territorial authority. Concerned about the growing Chinese presence in Korea, it had intervened to establish a pro-Japanese government there and to drive the Chinese from the peninsula. To defend Japan's growing imperialist aims, Japanese opinion makers adopted the political and visual language of contemporary European colonialists. China was declared to be "ignorant of proper international methods" and to "not want the progress of civilization." "This [was] not a war between people and people and country and country . . . but it [was] a kind of religious war."[3] Rather than asserting the primacy of its own indigenous pictorial tradition during a period of conflict with a foreign enemy, Japan embraced Western modes of visuality and developed a new European-influenced iconography for its images of military confrontation. Ironically, these newly imported conventions, which were more realistic than those found in traditional prints and paintings, enabled domestic audiences to feel reassured, wrongly or rightly, that they were being kept abreast of developments by receiving information that purported to be coming directly from the front. Adoption of this practice also meant that audiences in the West, who felt comfortable with the pictorial mode, were more accepting of these illustrations than they were of prints with unfamiliar colors and perspectival systems, and thus more open to the point of view that the Japanese wanted to promote. So effective was this process during the Sino-Japanese War in satisfying the needs of multiple constituents that subsequent generations of Japanese artists were to adopt its visual language during clashes from the Russo-Japanese War through the mid-twentieth-century conflicts in the Pacific.

THE PRECEDENTS FOR BATTLE IMAGERY DURING THE NINETEENTH CENTURY

Before the Sino-Japanese War, the Japanese did not use a consistent approach to the presentation of the contemporary battlefront. Although the imagery of Meiji-era artists such as Kobayashi Kiyochika (1847–1915), Toyohara Chikanobu (1838–1912), Mizuno Toshikata (1866–1908), and Ogata Gekkō (1859–1920) has most frequently been discussed as part of a woodblock tradition of battle scenes, the depiction of contemporary wars was only a nineteenth-century creation. Prior to that time, during the preceding Edo period (1615–1868), the government, under the

leadership of the Tokugawa shogunate that feared sedition, suppressed illustrations of all contemporary political figures and proscribed all commentary on the events of the day.[4] Artists had to resort to recasting the narratives of their own time in the historical terms of analogous precedents. It was not until the mid-nineteenth century, with the dramatic political and social transformation of Japan under the Meiji government, that political events came to be acceptable and even desirable subjects of imagery. For example, conscious of the manner in which European countries exploited pictures of their royal families to bolster strong national identities, the Japanese government promoted the production of woodblock prints that documented the newly Westernized Meiji emperor and empress attending national expositions of industry or presiding over the promulgation of the constitution. Like Austria's Franz Joseph I or France's Napoleon III, the Meiji emperor was often depicted standing in command over the army and navy as symbols of the modern Japanese state.

In the early Meiji era, two major military campaigns took place: the expedition to Taiwan in 1874, during which the Japanese set out to retaliate against the islanders for slaying Ryūkyūan sailors, and the Seinan War in 1877, an insurrection in southern Kyūshū led by General Saigō Takamori against the Meiji government. During both conflicts, domestic demand for information was high. Reporters from the *Tokyo nichi nichi shinbun* (Tokyo Daily Newspaper) and other newspapers strove to provide as up-to-date accounts as military censors and the communications systems would permit. Thus, Kishida Ginkō (1833–1905), considered Japan's first foreign correspondent, accompanied the army to Taiwan. Fukui Gen'ichirō (1841–1906), portrayed in a well-known woodblock print by Kobayashi Kiyochika, was embedded in the government army that later set out to quell Saigō's rebellion and reported the movements of the troops directly to the emperor.

Although journalists were given limited access to the battlefront, artists were more restricted. The photographer Matsuzaki Shinji was one of the few who were able to accompany the troops in Taiwan, and he brought back images that enjoyed wide popularity.[5] Lithographers and painters such as Shimooka Renjō (1823–1914) who had remained in Tokyo, however, were forced to re-create Matsuzaki's sepia-toned photographs of the skirmishes. These translations frequently depended on European artistic techniques and pictorial conventions, which in nineteenth-century Japan were thought to be more accurate in their description of the visible world.

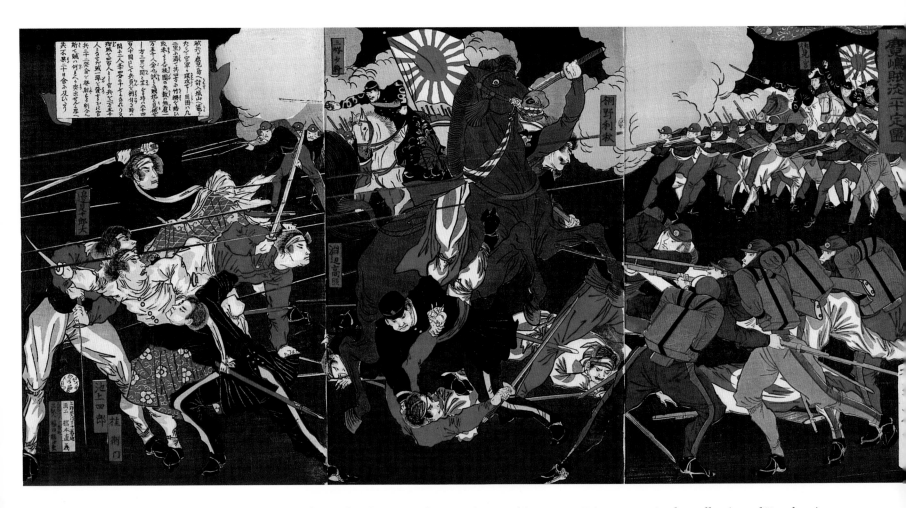

Toyohara Chikanobu (1838–1912)
Illustration of the Rebels Being Suppressed
at Kagoshima
Japanese woodblock print triptych, October 4, 1877

Shimooka, for example, experimented in oils with the dark Barbizon school palette recently introduced to Japan by the Italian artist Antonio Fontanesi (1818–1882). He created a seemingly naturalistic rendition of the mountain battlefield with its shallow stream and narrow passes in *The War in Taiwan*, now in the collection of Yasukuni Shrine, Tokyo.[6]

During these early military campaigns, however, the mode of visualization did not necessarily follow a prescribed pattern. To satisfy the demand for images of the civil war in Kyūshū, traditional ukiyo-e artists

were immediately called upon to produce brightly colored woodblock prints of Saigō's rebellion in great numbers. Edward Sylvester Morse, the Bostonian anthropologist and ceramic collector, noted that they were "brilliant in reds and blacks, the figures of the officers in most dramatic attitudes," and Hearn remarked that many were "rudely and cheaply executed, and mostly depicting the fancy of the artist only, but well fitted to stimulate the popular love of glory."[7] One of the more effective of these woodblock prints is *Illustration of the Rebels Being Suppressed at Kagoshima*, by Toyohara Chikanobu, in which one of the rebel leaders, Kirino Toshiaki, mounted on a brown steed, futilely wields his sword against the surrounding government troops led by Prince Fushimi. Set off against a black background, the composition becomes a whirl of spirited combat. The theatricality of the print, like so many of its time, in all certainty was strongly reinforced by the concurrent enthusiasm for the largely fictional version on the kabuki stage. In contrast, other artists trained in Western painting, such as Yamamoto Hōsui (1850–1906), provided their own versions of the Seinan War. Unable to accompany the infantrymen, they preferred to create their own fanciful reconstructions of the battles based on Barbizon-style oil paintings or engravings.

THE SINO-JAPANESE WAR (1894–95)

Although the government led by Prime Minister Itō Hirobumi was originally reluctant to engage China in battle, many members of the Japanese intelligentsia and the press were eager for a confrontation. Contemptuous of their continental neighbors for their failures to modernize and to contain Western colonialism, these opinion makers felt compelled to establish the sovereignty of their country and to assume the role of "Champion of Progress in the East," even if it required the use of might.[8] Articles in newspapers called for immediate military action, and once the government had committed itself to battle in August 1894, euphoria overtook Japan. The quick succession of crushing triumphs by the army and the navy during the ensuing months against the once-dominant China only heightened Japan's conviction of the rightness of its position and incited expressions of growing nationalist pride.

As it would do again ten years later during the Russo-Japanese War, the Japanese government immediately passed regulations to try to maintain strict censorship concerning the movements of the troops once the Sino-Japanese War began. All correspondents were forced to come under the direct supervision of the military, and all articles

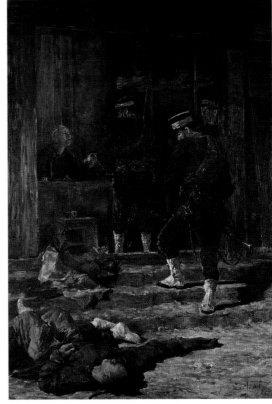

Asai Chū (1856–1907)
Captain Higuchi Rescuing a Child
Japanese oil painting, 1895

RIGHT

Asai Chū (1856–1907)
Searching after the Combat in Port Arthur
Japanese oil painting, 1895

had to be submitted for formal approval by the ministers of war.[9] At least sixty-six newspapers, however, decided to send correspondents to cover the battlefront. Not only were more than one hundred reporters delivering articles to their Tokyo offices but also eleven artists and four photographers were dispatched to provide images.[10] Among those artists who traveled with the army were the pioneers of Western-style oil painting in Japan. Yamamoto Hōsui, who had produced images of the Seinan War, was joined by Asai Chū (1856–1907), Koyama Shōtaro (1857–1916), and Kuroda Seiki (1866–1924)—men who had either studied with Fontanesi or gone to Paris to train at the Académie Julien. Extremely supportive of their nation's war efforts, these men were determined, as Asai declared, to "depict the real situation in the army and . . . paint what words do not well attain so as to compensate for the deficiencies in historical records for later times."[11] Evading their military overseers, however, was more

difficult than the artists had anticipated, and they were largely confined to the sidelines.

Despite the difficulties of access, Asai did try to provide as detailed an account as possible of his experiences in Korea and northern China. Sketching with pencil and pen and then highlighting his compositions with watercolors, he provided almost idyllic views of the soldiers on patrol around the gates of Taedong and the fortress at Jinzhou (Kinchow).[12] His more formal oil paintings of the war exploited his Barbizon school training. A dark-toned canvas now in the Tokyo National Museum depicts the aftermath of the battle at Port Arthur in November 1894. Displayed the following year at the Fourth Domestic Industrial Exposition and the Seventh Exhibition of

the Meiji Art Association (Meiji Bijutsukai), the composition shows Japanese soldiers making their way past a fallen Chinese man—now a grim reminder of the reported Japanese atrocities against Chinese civilians. Another, similarly colored oil painting dating from 1895 documents the return by Captain Higuchi, the commander of the Sixth Brigade and one of Japan's war heroes, of a Chinese child whom he had rescued from the battlefield at Motianling.[13]

Kuroda Seiki, who was attached to the Second Army division led by General Ōyama as it battled through the Liaodong Peninsula in Manchuria, also executed four volumes of informal pencil and pen sketches that portray soldiers patrolling the fortress at Jinzhou and members of the Red Cross

Kuroda Seiki (1866–1924)
Informal Views of the Japanese Troops in China
Japanese ink drawing, November 25, 1894

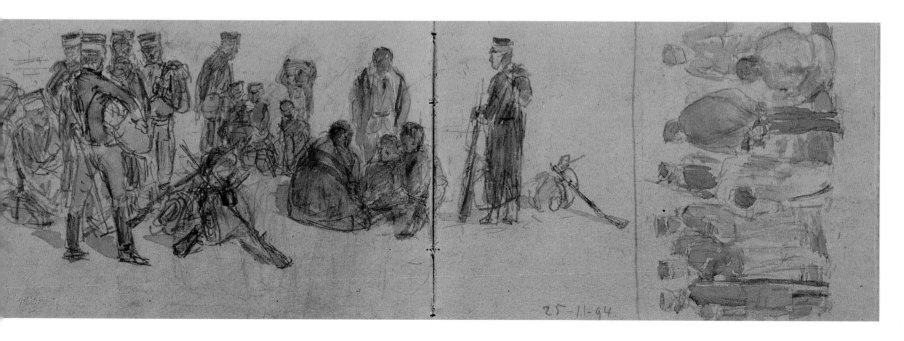

25-11-94

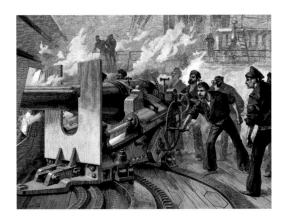

"Life on Board of a Man-of-War, Practice with a Six-Inch Breech-Loading Gun—'A Hit!'" from the Illustrated London News, *May 18, 1889*

RIGHT

Mizuno Toshikata (1866–1908)
Japanese Warships Fire on the Enemy near Haiyang Island
Japanese woodblock print triptych, 1894

waiting for their orders. Although there are no battle scenes, the renditions of the army's activities conveyed the everyday lives of the troops.[14] Having just returned from ten years of study in France, Kuroda finished many of these sketches for illustrations of the front for the French newspaper *Le Monde Illustré*.

INSISTENCE ON A NEW VISUAL MODE

The promotion of a Western mode of visualization by artists who were trained by painters from abroad is not surprising. However, elements of European-influenced description can also be found in the works of artists who supposedly had only traditional training. Kubota Beisen (1852–1906) and his sons Kinsen (1875–1954) and Beisai (1874–1937) accompanied the First Army division, which made the initial advances

across the Korean Peninsula in 1894, and provided illustrations for the *Kokumin shinbun* (National Newspaper). In the well-known woodblock print *Hurrah! Hurrah! For the Great Japanese Empire! Picture of the Assault on Songhwan, a Great Victory for Our Troops*, dating from 1894, Mizuno Toshikata imagines Beisen and Kinsen standing behind the Japanese army lines, directly observing the attack on the Chinese fortress. In their ten-volume *Illustrated Record of the Battles of the Sino-Japanese War*, from 1894–95, Beisen and his two sons describe the events of the war against a landscape that is beholden to East Asian literati painting and prints, with fibrous texture strokes used to define mountainsides and riverbanks and stippling to suggest the foliage on the trees. Yet the artists have consistently modeled the figures of the Japanese soldiers with lights and darks to heighten the solidity of their forms. This

modeling contrasts with the time-honored use of simple hooked outlines to define the figures of the Chinese combatants.

Traditional artists who had clearly not traveled to the battlefront used Western artistic conventions such as a level horizon line, shading to create a sense of volume, foreshortening, and the use of a constant light source to great effect; these conventions conveniently conveyed an immediacy of observation. For example, although he remained in Tokyo, Mizuno "documents" the assault in September 1894 on the Chinese fleet in the Yellow Sea in the print *Japanese Warships Fire on the Enemy near Haiyang Island*. He underscores the massiveness of the rapid-firing gun, which played a critical role in the defeat of the Chinese ironclad battleships, with a heightened use of shading. Furthermore, he models unique facial features for the enlisted men and their commanders in an attempt to convey the individuality of each person who participated in the attack. For this composition with the breechloading gun, Mizuno in fact quoted directly from a picture of British sailors huddled around an artillery gun while performing naval maneuvers from the *Illustrated London News* dating to May 18, 1889; only the minor detailing of the facial features and the uniforms was revised. The Western visuality of the newspaper illustration plainly helped provide authenticity for Mizuno's otherwise fictional work.[15]

Although there is little written commentary about these decisions by popular artists to incorporate Western elements into the Japanese rhetoric of battle in the last decade of the nineteenth century, contemporary images clearly indicate that it was done consciously. The world of war, with its male protagonists—the domain that engaged with the Western world—was expressed in Western visual language. The world of the home front of the waiting wives and mothers—the domain that preserved traditional values—was detailed in the conventions that had long been popularized by generations of woodblock print artists. Kobayashi Kiyochika, who had studied oil painting with the British illustrator Charles Wirgman (1832–1891) and scroll painting with Kawanabe Kyōsai (1831–1889), provides evidence of these choices in his triptych *A Soldier's Dream at Camp during a Truce in the Sino-Japanese War*, from 1895. In the lower left of the composition an infantryman lies asleep on a rough straw pallet inside his tent in a military camp. To his right is juxtaposed a vignette outlined in a scalloped cloud presenting a sentimental vision of his desired return to his home and to his supportive family in Japan. The subtly shaded Europeanized features of the foreshortened recumbent soldier contrasts with the women of his household, who are shown with the tradi-

Kubota Beisen (1852–1906)
Kubota Beisai (1874–1937)
Kubota Kinsen (1875–1954)
Illustrated Record of the Battles of the Sino-Japanese War
Japanese woodblock-printed album, 1894–95

Kobayashi Kiyochika (1847–1915)
A Soldier's Dream at Camp during a Truce in the
Sino-Japanese War
Japanese woodblock print triptych, April 1895

tional abbreviated features of lines for the eyes and a hook for the nose.

During the Russo-Japanese War, artists similarly were known to select one of the two modes of illustration depending on the subject matter. Suzuki Kason (1860–1919), who was trained in the traditional painting styles of the Maruyama-Shijō and Tosa schools, explored the same dichotomy of pictorial styles in his 1904 illustrated preface for the magazine *Bungei kurabu* (Literary Club), entitled "Shedding Tears While Thinking of Husband in the War." A Japanese woman with features that are indebted to mid-nineteenth-century woodblock prints—narrow, expressionless eyes and an aquiline nose—is juxtaposed with a vignette of soldiers who are shown as having a more Western appearance.

Although there is no accompanying text, a short piece in the *Illustrated London News* dated December 29, 1894—entitled "How

Japanese War Pictures Are Made"—underscores how widespread the Japanese practice of borrowing elements from Western prints must have been. The juxtaposition of an illustration of the 1885 Battle of Kerbekan in the Sudan with a woodblock print by an unidentified Japanese artist of the 1894 rout of Jinlengzhang makes clear that Japanese printmakers even turned to much earlier depictions of Western colonial wars to develop their own iconography of foreign conquest. The arrangement of the landscape settings with the walled enemy fortress in the background and the groupings of the converging troops in the two works are almost identical. The artist also adopted the melodramatic lighting exploited by the artist of the African conflict.[16]

Two themes that were frequently depicted in woodblock prints, newspaper illustrations, lithographs, and textiles during the Sino- and Russo-Japanese Wars—the heroic individual and the compassionate warrior—were also taken from nineteenth-century European war imagery. From the time of the Crimean War (1854–56), when middle-class England had become disillusioned by the incompetence and arrogance of its privileged leaders, the common soldier, rather than the aristocratic commander, had been celebrated in battle accounts.[17] The moral certitude of the exemplary soldier, a man with knightly virtues who did battle with a "barbarian" enemy, provided somewhat sanctimonious justification for the imperialist conflicts of the British. John Ruskin, the renowned British art critic, declared that colonial wars were "an allegory of the life of the individual and of the true society of believers, bringing light to surrounding darkness. Though national in import, war should be a matter of individual heroism, not of massed ranks hurling themselves at an enemy."[18] The adoption of this kind of European heroic ideal served to align Japan with the values of the community of modern nations and to support its growing international ambitions to "civilize" its neighbors. It also served to bolster domestic support for the newly instituted military conscription system. During the Sino-Japanese War, Captain Matsuzaki Naoomi, who persevered at the battle outside Songhwan despite having been shot through the leg; the bugler Shirakami Genjirō, who with his dying breath continued to sound the call to arms during the battle at Songhwan; and the private Harada Jūkichi, who courageously scaled the walls of the fortress at P'yŏng'yang (Pingyang) and opened the gates while fending off the enemy, were hailed for their gallantry. Likewise, Commander Hirose Takeo, who selflessly went below the deck of the torpedo-torn battleship *Fukuimaru* to

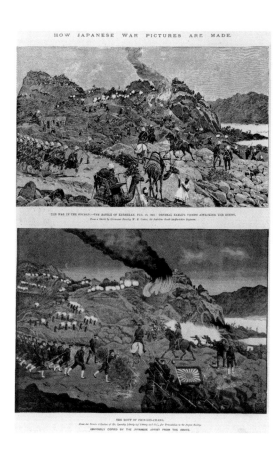

"How Japanese War Pictures Are Made," from the Illustrated London News, *December 29, 1894*

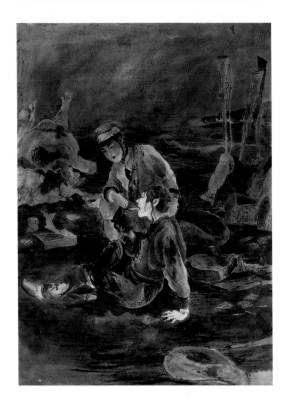

rescue his comrade before being felled by a Russian shell, was heralded during the Russo-Japanese War.

During the Crimean War, Florence Nightingale, who revolutionized the treatment of the wounded, had been celebrated as one of the heroines of the conflict. The historian Matthew Paul Lalumia described her as "a distinctly modern figure . . . who in her industry and charity embodied the highest values of mid-Victorian society."[19] Images of the pioneering nurse had frequently appeared in British newspaper illustrations and popular prints. Similarly, Clara Barton, who founded the American Red Cross, had been lauded as the "Angel of the Battlefield" for her treatment of the casualties during the Civil War five years later.

As part of Japan's efforts to emulate Western institutions, the Japanese Red Cross was established in 1877, during the Seinan War. By the time of the Sino-Japanese War, images of the Red Cross tending to fallen soldiers had become part of the standard iconography of the battlefield; the Japanese were to be seen as not only mighty but also magnanimous, as befitted an "enlightened" nation. Such descriptions would only proliferate during the Russo-Japanese War, with the Japanese Red Cross shown selflessly caring for Japanese and Russian wounded alike.

Signed "Toshimitsu"
After the Battle: Kindness to the Fallen Foe
Japanese illustration, about 1904

RIGHT

Utagawa Kokunimasa (Ryūa, dates unknown)
Russo-Japanese War: Great Japan Red Cross Battlefield Hospital Treating the Injured
Japanese woodblock print triptych, March 1904

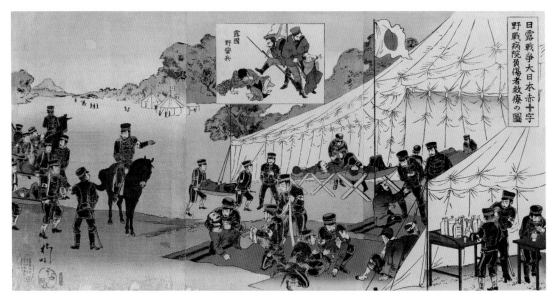

Artist unknown
Nurse and Soldiers
Japanese postcard, 1906

Artist unknown
Nurse Holding a Cherry Blossom Branch
Japanese postcard, about 1904–05

Artist unknown
Nurse and Lily
Japanese postcard, canceled 1905

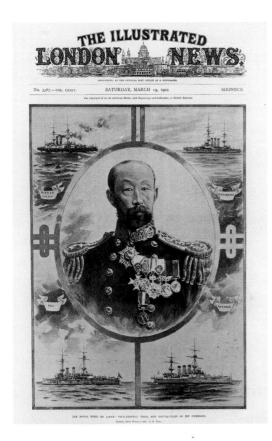

Front page of the Illustrated London News, *March 19, 1904*

THE RUSSO-JAPANESE WAR: A BATTLE OF IMAGES

By 1900, when tensions were building with the Russians, the Japanese government had become acutely aware of the necessity to develop networks of information throughout Europe and the United States in order to manage Western public opinion. Its foreign legations carefully disseminated news of diplomatic developments to the Western press, and well-connected statesmen, such as the Harvard-educated Kaneko Kentarō, were dispatched on speaking tours to reassure the Western public of the "civilized" position of the Japanese.[20] When war eventually was declared in February 1904, the Japanese tried even more strenuously to manage their image by restricting the access of foreign correspondents to the front. There was worldwide interest in the war, however, and journalists and artists came from all over to cover it. One contemporary American account of the war read: "The Russo-Japanese War was notable for the fact that . . . there were more able men on the spot ready to transmit the daily happenings to a waiting world than there have been in any other war in modern times."[21] The scholar Robert Valliant determined that within one month of the outbreak of the war, at least fifty-three correspondents (including twenty-nine from Great Britain, seventeen from the United States, five from France, and two from Germany) descended on Japan.[22]

Although for months the Japanese government largely confined these correspondents to Tokyo, where they could report only on the home-front reactions to the developments on the battlefield, foreign as well as domestic newspapers were eager to obtain images of the fighting. Robert L. Dunn, who had been dispatched by *Collier's*, a New York weekly, was one of the few photographers able to evade the censors and capture images of the military maneuvers in Korea. Other newspapers such as the *Illustrated London News*, however, were largely prevented from sending their own observers. Despite these limitations, by March 19 the front page of the *Illustrated London News* featured an image of Vice Admiral Tōgō Heihachirō and vignettes of the naval battles outside Port Arthur. All of these were facsimiles of lithographs published in Japan. Issues from later weeks featured other illustrations that had been redrawn from sketches by unnamed Japanese artists. Employing the iconography of battle and the mode of representation that had been developed by the West, Japan was able to provide images that were immediately acceptable to its European and American counterparts and that were an effective

means by which the Japanese could present themselves.

Two woodblock prints by Kōkyo (active 1877–1904) of the engagement at Port Arthur on February 14, 1904, during which Japanese torpedo boats attacked Russian men-of-war at the entrance to the harbor, demonstrate to what extent Japanese artists were aware of the foreign audiences for their compositions. In the first version, which was made for domestic consumption, a listing Russian vessel sends out a searchlight into the stormy night. Smaller Japanese boats barge through the roiling waves toward their target. A cartouche in the right panel of the triptych relates in Chinese characters the particulars of the event. A second version, seen here, bears an inscription in English across the center of the otherwise identical composition. It reads "The Japanese Russian War No. 2, Naval Eight before the Harbour of Port Arthur, the Russian Men-of-War Torpedoed by the Japanese Aquadron" and clearly declares for the Western world Japan's initial military successes.

The extent to which the Japanese desired to position themselves as the equals of the Western powers is also evident in the woodblock prints of the battlefront. Images by Getsuzō (active 1904–1905) such as *A Fight at the Yalu River* and *By Destroying the Enemy Wire Entanglements [Japanese Forces] Capture the Enemy Fortress at Nanshan* not only perpetuate the modes of Western visuality that had been adopted by the time of the Sino-Japanese War but also present the Japanese soldiers with decidedly Western facial features. The prominence of the figures in the foreground and the black

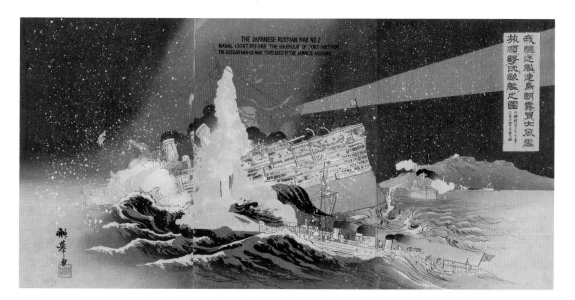

Kōkyo (active 1877–1904)
Illustration of Our Destroyers *Hayatori* and *Asagiri* Sinking Enemy Ships at Port Arthur during a Great Snowstorm at 3:00 a.m. on February 14, 1904
Japanese woodblock print triptych, February 1904

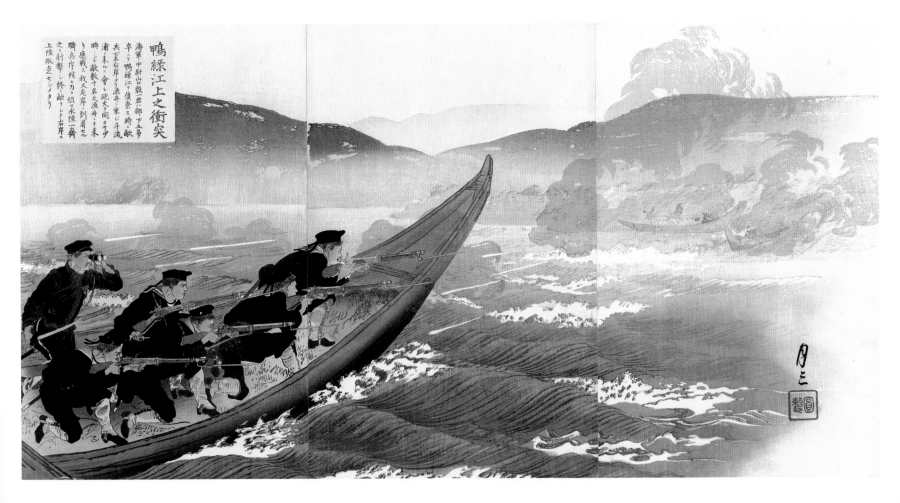

鴨緑江上之衝突

海軍中尉山懿ノ君一部下五多
辛ラ鴨緑江ノ偵察ス時ニ敵
兵既右岸ヨリ漁舟ニ東シ斗流
浦來ル會シ砲火ノ開々ヒ
時ニ敵数十大漁舟ヲ来
リ應戦ス敵又兄岸ニ到着花
騎兵ノ作恢ヲ力ヲ恨水陸一齊
之ヲ射撃シ鉄ノ敵ノシ右岸ヲ
上陸販达ゼセンタリ

Getsuzō (active 1904–1905)
A Fight at the Yalu River
Japanese woodblock print triptych, June 1, 1904

uniforms become the primary identifying features of the Japanese combatants.

As Lafcadio Hearn described, images of the Russo-Japanese War were available in unprecedented numbers and formats. By the early twentieth century, woodblock prints and newspaper illustrations were gradually being supplanted by photographs; the modern gaze of the camera established a "new authenticity" for Japan's reportage of its feats on the battlefield. The introduction of the postcard from Europe, which lent itself to editions of four hundred thousand to seven hundred thousand and could be ex-

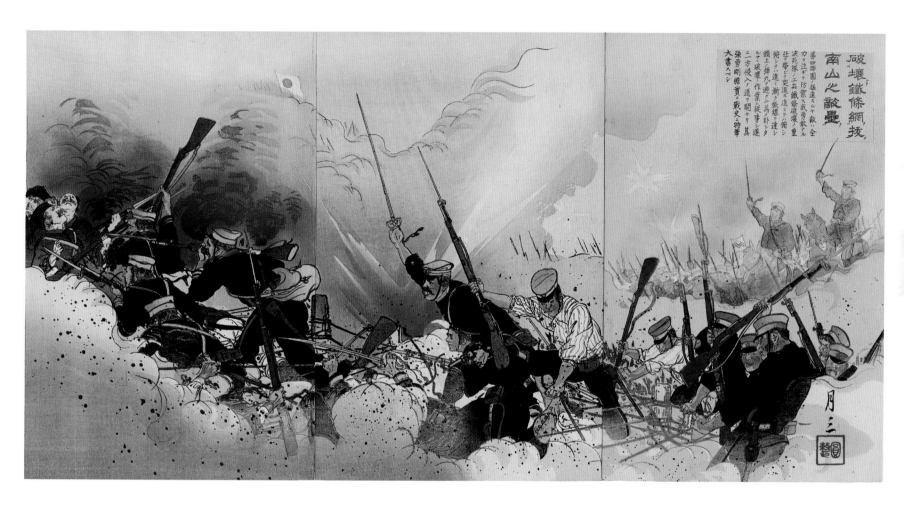

破壊鐵條綱ノ技
南山ノ鏖戰

第四師團ノ猛進スルヤ敵ハ全
カヲ注ヰテ防禦スルモ我勇敢ナル
決死隊ノ工兵鐵條綱ヲ破壞ノ重
任ヲ帶ヰテ突進ス進ミニ備ヲ
俯シテ進ミ斷ヲ鐵綱ヲ達シ
頭上ニ彈丸ノ逆ゲルヲ爲ニ臥シタ
ルヲ破壞作業ニ從事シ遂
ニ方陵人ニ道ヲ開ケ其
強勇剛膽賞スニ戰史ニ特筆
大書スベシ

changed easily with overseas correspondents, helped to underscore the impression that Japan wanted to convey to the West. Textiles and candy boxes emblazoned with portraits of wartime heroes served to bolster the appearance of a nation united in purpose. As they fought to establish Japan's place among the international powers, the leaders of the Russo-Japanese War, unlike their Edo-period predecessors, found that it was the dissemination of images rather than their suppression that afforded them the greatest degree of political control.

Getsuzō (active 1904–1905)
By Destroying the Enemy Wire Entanglements [Japanese Forces] Capture the Enemy Fortress at Nanshan
Japanese woodblock print triptych, printed September 20, 1904

NOTES

1. Lafcadio Hearn, "A Letter from Japan," in *Gleanings in Buddha-Fields and the Romance of the Milky Way* (1905; reprint, Boston: Houghton Mifflin, 1923), 347.

2. Lafcadio Hearn, *Kokoro* [1896] reprinted in *Out of the East and Kokoro* (Boston: Houghton Mifflin, 1923), 332–36.

3. Fukuzawa Yūkichi (1834–1901), one of Japan's leading advocates for Westernization, is quoted in *Creating a Public: People and Press in Meiji Japan*, by James L. Huffman (Honolulu: University of Hawai'i Press, 1997), 202.

4. Sarah E. Thompson, "The Politics of Japanese Prints," in *Undercurrents in the Floating World: Censorship and Japanese Prints* (New York: Asia Society, 1991), 29–91, and D. Eleanor Westney, *Imitation and Innovation: The Transfer of Western Organizational Patterns to Meiji Japan* (Cambridge, Mass.: Harvard University Press, 1987), 147.

5. Ozawa Kenshi, ed., *Shashin Meiji no sensō* (Tokyo: Chikuma Shobō, 2001), 38.

6. For an excellent introduction to the imagery of the Taiwan, Seinan, Sino-Japanese, and Russo-Japanese Wars, see Kinoshita Naoyuki, "Sensō no zōkei," in *Egakareta rekishi* (Kobe: Hyōgō Kenritsu Bijutsukan; Kamakura: Kanagawa Kenritsu Kindai Bijutsukan, 1993), 103.

7. Edward Sylvester Morse, *Japan Day by Day*, 1877, 1878–79, 1882–83 (Boston: Houghton Mifflin, 1917), 1:281, and Hearn, "Kokoro," 91.

8. Uchimura Kanzō (1861–1930), a well-known Meiji-era Christian thinker and editorialist, quoted in Donald Keene's "The Sino-Japanese War of 1894–95 and Its Cultural Effects in Japan," in *Tradition and Modernization in Japanese Culture*, ed. Donald H. Shively (Princeton: Princeton University Press, 1971), 128.

9. Huffman, *Creating a Public*, 206.

10. Ibid., 208.

11. Asai Chū, quoted in John Clark's "Artists and the State: The Image of China," in *Society and the State in Interwar Japan*, ed. Elise K. Tipton (London: Routledge, 1997), 71.

12. *Asai Chū* (Chiba: Chiba Prefectural Museum of Art, 1998), illustrations 35–42.

Artist unknown
Picture Postcards Commemorating the Battle of the Japan Sea
Japanese postcards, 1905

Artist unknown
Textile printed with design of Russo-Japanese War
postcards
Japanese, about 1905

13. Captain Higuchi was the subject of many contemporary woodblock prints as well. See Ogata Gekkō's *Illustration of Captain Higuchi Holding a Chinese Orphan While on His Way to Making an Attack*, 1895, Jean. S. and Frederic A. Sharf Collection, 2000.14, Museum of Fine Arts, Boston.

14. For a discussion of the diary that Kuroda kept while stationed in Manchuria and for reproductions of his sketches, refer to Kumamoto Kenjirō, "Kuroda Seiki to Nisshin sensō yaku," in *Kindai Nihon bijutsu no kenkyū* (Tokyo: Tokyo Bunkazai Kenkyūjō, 1964), 298–307.

15. During the Russo-Japanese War, artists were also known to appropriate images from the Sino-Japanese War to depict contemporary events to which they did not have access. For example, an unknown printmaker documenting the negotiations about Manchuria in 1903 substituted Russian delegates for the Chinese ambassadors who met with the Japanese prime minister Itō Hirobumi, depicted in a Sino-Japanese triptych by Utagawa Kokunimasa. See illustrations in Konishi Shirō's *Nishiki-e Bakumatsu Meiji no rekishi*, vol. 11, *Nisshin sensō* (Tokyo: Kodansha, 1977), 74–75, and vol. 12, *Nichirō sensō*

zengo (Tokyo: Kodansha, 1978), 40–41. Charles Lowenhaupt's observation of Toshikata's indebtedness to the *Illustrated London News* picture was kindly forwarded to the author by Sebastian Dobson.

16. The passage in the *Illustrated London News* has been previously cited by Elizabeth de Sabato Swinton in *In Battle's Light: Woodblock Prints of Japan's Early Modern Wars* (Worcester, Mass.: Worcester Art Museum, 1991), 21.

17. For an analysis of this development, see Matthew Paul Lalumia, *Realism and Politics in Victorian Art of the Crimean War* (Ann Arbor, Mich.: University of Michigan Research Press, 1984).

18. John M. MacKenzie, ed., *Popular Imperialism and the Military, 1850–1950* (Manchester, England: Manchester University Press, 1992), 5–6.

19. Lalumia, *Realism and Politics*, 90.

20. Robert B. Valliant, "The Selling of Japan: Japanese Manipulation of Western Opinion, 1900–1905," *Monumenta Nipponica* 29, no. 4 (Winter 1974), 415–38.

21. *The Russo-Japanese War: A Photographic and Descriptive Review of the Great Conflict in the Far East* (New York: P. F. Collier & Son, 1905), 87.

22. Valliant, "The Selling of Japan," 431.

SEBASTIAN DOBSON

Reflections of Conflict

Japanese Photographers
and the Russo-Japanese War

When the lengthy siege of Port Arthur that turned the Russo-Japanese War decisively in Japan's favor came to an end on January 1, 1905, Japanese image makers rendered the important victory in several ways. Printmakers operating in the media of woodblock and the lithograph reimagined the scene of General Nogi meeting with his Russian counterpart, General Stoessel, with varying degrees of accuracy, but the photographers accompanying the Japanese army fixed the moment more indelibly. One photograph in particular, showing the two generals and their staff seated side by side, enjoyed a far wider circulation in Japan than the traditional multicolored woodblock print or the newer lithograph and became a defining image of the Russo-Japanese War. An even more vivid representation of the occasion became available to audiences through the recently invented cinematograph, by which a reel of the formal surrender, taken by a unit of Japanese filmmakers, was shown in improvised motion-picture houses nationwide.

These images were just part of a phenomenon that made the Russo-Japanese War one of the most observed conflicts of the modern age. Certainly few wars before or since commanded such a wide range of visual media, foremost among which was photography. Recent developments in printing technology enabled the photographic image to be broadcast not only in traditional formats, such as the photographic print or the paired stereograph that gave a three-dimensional effect when viewed with the appropriate equipment, but also in a variety of new, more accessible formats, including the newspaper or magazine illustration, the postcard, and, perhaps most exciting of all, the cinematograph. The Japanese public was bombarded with photographic images of a modern conflict in which their armed forces were participating, and a new chapter in Japanese photography was opened both technologically and in terms of how new technology could be used to shape public opinion.

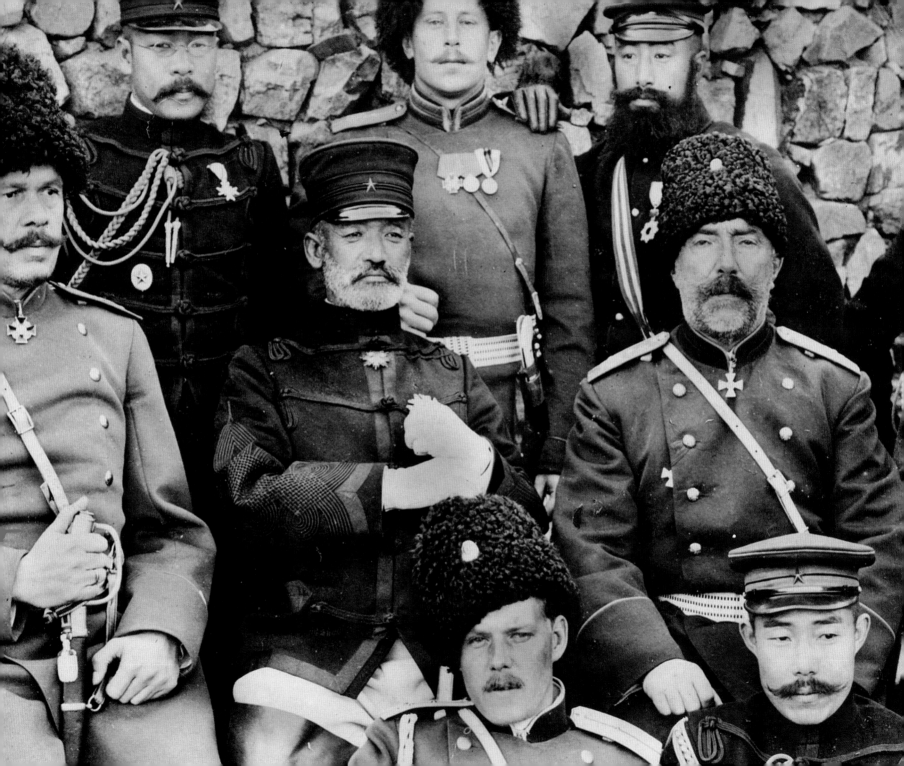

WAR PHOTOGRAPHY IN JAPAN BEFORE THE RUSSO-JAPANESE WAR

If war photography can be defined broadly as taking a camera into a war zone, then Tokugawa Yoshikatsu (1824–1883), head of the Owari clan and a relation of the ruling shogunal dynasty, may have been the first Japanese war photographer. On the eve of the Meiji Restoration, Tokugawa shared an interest in photographic research with Tokugawa Nariaki, lord of the Mito clan and father of the last shogun, and Shimazu Nariakira, lord of the Satsuma clan. In the summer of 1864, when Tokugawa's official duties required him to command a punitive expedition against the Chōshū clan, he arrived at his headquarters in Hiroshima Castle with a camera.[1] The task of leading an army in the field, combined with the unwieldy photographic techniques of the time, prevented him from shooting what we would recognize today as war photographs, but during the desultory stage of the campaign, he succeeded in taking several views of Hiroshima and his headquarters.[2]

Following the Meiji Restoration of 1868, the newly created Imperial Japanese Army showed itself to be quite amenable to allowing photographers to record its campaigns. In 1874, two civilian photographers, Matsuzaki Shinji and Kumagai Shin, accompanied the Japanese expeditionary force in its campaign against the Taiwanese aborigines. Battling against heat and malaria while their hosts fought unsuccessfully against the aborigines, Matsuzaki and Kumagai produced photographs of the fighting and, whenever possible, portraits of the local inhabitants. Their portfolio, which was later advertised as consisting of thirty-nine prints, was achieved at a high price: both photographers were debilitated by fever, and Kumagai later died during the campaign, leaving Matsuzaki to oversee his cremation and burial. Curiously, with one or two possible exceptions, the photographs taken by Matsuzaki and Kumagai have never been found. To date, the Taiwan Expedition of 1874 has its greatest claim to significance in the history of photography as the first instance in which a Japanese photographer lost his life in action.[3]

It fell to another group of civilian photographers operating three years later to produce the earliest surviving photographic record of the Japanese army on campaign. In February 1877, the Satsuma clan rebelled against the central government, and in the course of the Southwestern Campaign (Seinan no Eki), which raged over the next seven months, most of the island of Kyūshū became a war zone in what would be Japan's last civil war. The commander of the government forces, Admiral Kawamura

Tsuneyoshi, employed two local photographers, Ueno Hikoma of Nagasaki and his friend and former pupil Tomishige Rihei of Kumamoto, to record its aftermath. Their photographs, taken at the scene of action immediately after the fighting was over, numbered at least 207 negatives and might be compared in style with that of Mathew Brady and the other field photographers who had documented the American Civil War from the Union side in the previous decade, especially in the evocative depiction of battle-scarred landscapes. The essential difference is that Ueno and Tomishige appear to have studiously avoided including scenes of the war dead in their portfolio. Nevertheless, the two Japanese photographers succeeded in creating a visual record of the campaign and in communicating some of the pathos of a civil war, although strictly speaking, their photographic record of the Satsuma Rebellion includes only battle sites and shows nothing of the actual fighting.[4]

A major limitation for Japanese war photographers at this time was the unwieldy wet-plate process, which required glass negatives to be prepared and sensitized in the field immediately before exposure and fixed immediately afterward in a darkroom tent. The process necessitated both a large supply of glass, chemicals, and equipment and a team of assistants and porters to provide technical support and sheer muscle. Ueno and Tomishige, for example, took to the field in 1877 with two assistants and eight porters. Another limitation was the photographer's own sense of technical pride, which did not allow any faults or blemishes. With exposure times varying anywhere between three and twenty seconds, a static subject was thus essential.

The Japanese army did not go on campaign again for another seventeen years, during which time technical advances were made in photography, in particular the invention of dry-plate negatives, which released photographers from the onerous task of treating negatives in the field. Yet, when the Sino-Japanese War broke out in August 1894, these changes were applied only selectively by the photographers who accompanied the Japanese army to China. A practical illustration of this selectivity is provided by a camera used by Count Kamei Koreaki, one of the photographers with the Japanese army, and which survives in the Kamei family archive in Shimane Prefecture. Weighing fifty-five pounds, the camera has a sizable, Japanese-made cherrywood body designed to accommodate *zenshi*-size glass-plate negatives, which, measuring just less than eighteen by twenty-two inches, were the largest commercially available negatives, and in Kamei's case were prepared using the wet-plate method. The only technical

advance employed by Kamei appears to have been an improved British-made shutter, which reduced exposure time to a more flexible range of between one-twentieth of a second and one second. Otherwise, little had changed since the Satsuma Rebellion, and the impedimenta required by Kamei and the five photographers who accompanied him to China consisted of six *zenshi*-size cameras and at least eleven cases of photographic equipment, all of which weighed 2,240 pounds.

The son of a member of the imperial court and educated in London and Berlin, Kamei represented the end of a tradition in Japanese photography, in which its earliest practitioners were either members of the feudal aristocracy or clan scholars dependent on that aristocracy for employment and sponsorship. Ueno, for example, the first professional photographer in Nagasaki if not Japan, was dependent on the aid of the lord of the Tsu clan for continuing the practical studies that eventually led him to establish his photographic studio in 1862. When the Sino-Japanese War broke out, Count Kamei petitioned the emperor for permission to accompany the Japanese army as part of a photographic unit paid for out of his own pocket. With the official approval of the Imperial Headquarters, or Daihonei, Kamei and the five members of his unit left Yokohama in the middle of October, and on October 24 they landed on the Liaodong

Peninsula, where they joined the Japanese Second Army under General Ōyama Iwao.[5] Over the following seven months, Kamei's photographic unit accompanied Ōyama's force on campaign, witnessing the fierce fighting at Jinzhou and Port Arthur, experiencing the bitter Manchurian winter, and taking in the process more than three hundred negatives.

In the meantime, a proposal had been submitted from within the Army General Staff to establish its own photographic unit. A plan was quickly put together by the Army Land Surveying Department, a section of the General Staff which had hitherto only analyzed photographs to draw up large-scale maps for military use. First Lieutenant Toya Kanejirō was placed in command, with two surveyors, Ogura Kenji and Murayama Yūsei, working under him.

Of the three, Ogura was the most accomplished. Although Ogura's social background is unclear, it is known that he set up his own photographic studio at the precocious age of fifteen. A major influence in his life seems to have been his elder brother Masateru, who, before joining the teaching staff at the Army Military Academy, appears to have studied photography under Shimooka Renjō, part of the first generation of Japanese (with Ueno) to learn photography from Western photographers living in Japan. It was Masateru who helped the

younger Ogura get a job as a technical assistant in the Surveying Department, where he served until the Sino-Japanese War broke out. Three days after Kamei landed in Manchuria, Lieutenant Toya, Ogura, and Murayama reported to the headquarters of General Ōyama's Second Army as the three-man Photographic Unit of the Land Surveying Department of the Army General Staff, and until May of the following year when the unit was recalled to Tokyo, they would take more than one thousand glass-plate negatives.

The creation of an official photographic unit within the Imperial Japanese Army was not the only development from the Sino-Japanese War that would reappear ten years later during the war with Russia. The war with China was the first of Japan's modern wars to be observed extensively by military attachés and press correspondents from the West. Both categories of foreign visitor were subject to restrictions in what they could see and, particularly in the case of the latter, what they could communicate to the outside world, but the Japanese military authorities seem to have been unprepared for the possibility that their foreign guests would seek to create their own photographic records of the Sino-Japanese War.

Technology had sufficiently advanced to make cameras more affordable, easier to use, and a lot more portable, and Georges Bigot, one of the correspondents with the Japanese army, and the special artist of the London magazine the *Graphic*, took a small folding camera with him to Manchuria. Bigot, who had lived in Japan since 1881 and made his name as an artist and caricaturist, not only seems to have used photography as a means of padding out the portfolio of illustrations he regularly sent to the *Graphic* in London and *Le Monde Illustré* in Paris but also occasionally based his drawings on some of the snapshots he took during the campaign. It was one of Bigot's supplementary snapshots that would reveal the danger of allowing an unauthorized foreign photographer, even an amateur one, too close to the battle zone.

On November 21, 1894, the Chinese stronghold at Port Arthur fell after a short siege, and the victorious Japanese troops made the grisly discovery of the mutilated bodies of their brothers-in-arms who had been captured by the Chinese. Enraged by these atrocities, the Japanese embarked on a massacre of the Port Arthur garrison, which, over the next few days, included the civilian population of the city as well. According to a contemporary British commentator:

> *The Japanese, officers and men alike, were carried far beyond what could be excused even by their finding the mutilated remains of their tortured friends exposed on the gateway of the*

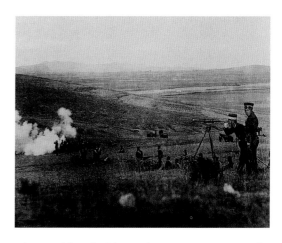

Photographic Unit of the Land Surveying Department of the Japanese Army
Japanese Artillery Bombing Port Arthur from Fang-gu-tun on November 21, 1894
Japanese photograph, 1894

town. *For four days, after the first, the massacre of non-combatants, of women, of children, was continued in cold blood, while European military attachés and special correspondents sickened at the wholesale murders and mutilations, which they could do nothing to prevent. . . . At last but thirty-six Chinamen* [sic] *were left alive in the city. They had been spared only to be employed in burying their dead fellow-countrymen, and each was protected by a slip of paper fastened in his cap, with the inscription: "This man is not to be killed."*[6]

News soon filtered to the outside world, and during the following month, newspapers in New York, London, and Paris reported on the atrocity with varying degrees of luridness while the Japanese Foreign Ministry undertook an exhaustive effort to limit the damage to Japan's reputation.

It was fortunate for Japan that photographs could not be communicated with the same ease as words, for Bigot had been among the small group of foreign correspondents who had been allowed to accompany the army to Port Arthur and had taken some snapshots of the massacre, at least one of which was sent to the *Graphic* in London. On February 2, 1895, the *Graphic* published one of the most gruesome of Bigot's photographs: a group of Japanese soldiers posing with drawn bayonets over Chinese bodies,

accompanied by the disclaimer that "the above illustration, despite its somewhat gruesome character, warrants publication in view of the recent discussion with regard to the occupation of Port Arthur by the Japanese." Conscious of the impact of this image, the magazine also displayed the original photograph in the window of its London office. Had technology enabled Bigot's photograph to have been published at the same time as the press reports circulating six weeks earlier, the Port Arthur massacre would have left an indelible mark on Japan's image abroad. The reaction of the Japanese military authorities to Bigot's photograph and its appearance in a British mass-circulation magazine is not known, but there can be little doubt that this episode provided a salutary lesson in the need to manage foreign correspondents and photographers when they sought to accompany the Japanese army a second time, in far greater numbers, during the Russo-Japanese War.

The two officially authorized photographic units, one headed by Count Kamei and the other by Lieutenant Toya, were also present at Port Arthur, and each unit left its own distinctive record. In contrast to Bigot's exploitative style (one can almost imagine him behind the camera shouting encouragement to the soldiers in the scene), Kamei was less sensational and more thoughtful, and a photograph entitled *The Burial of*

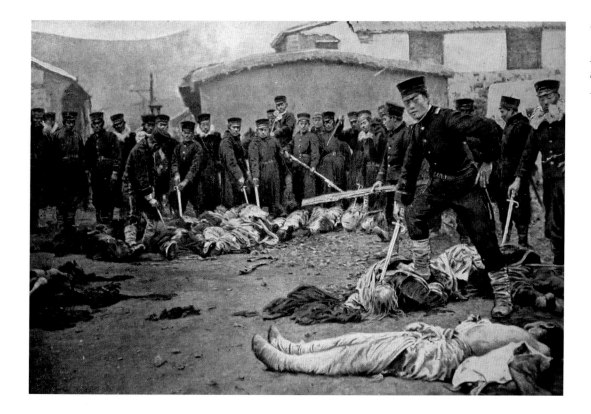

Georges Bigot (1860–1927)
"The Fall of Port Arthur: The Entry of the Victorious
Army, from a photograph sent by our special artist with
the Japanese Forces," from the Graphic *(London),*
February 2, 1895

Enemy Dead in a Field on the Northern Outskirts of Port Arthur shows instead graves being dug behind a large group of Chinese corpses while Japanese soldiers look on. Only one photograph taken by the Photographic Unit of the Land Surveying Department at the time appears to have survived; it consists of a distant view of the city taken from one of the surrounding heights on November 23, offering no hint of what has taken place.

The dissemination of each image is a lesson in how photography was becoming a mass medium. Undoubtedly, Bigot's snapshot reached the widest audience, photolithography enabling its reproduction in a British weekly magazine that was rivaling the previously indomitable *Illustrated London News* in terms of popularity. In Japan, the same ease of circulation could be seen in trimonthly war magazines published by Hakubunkan and Shunyōdō. By contrast, Kamei's photographs of the war never

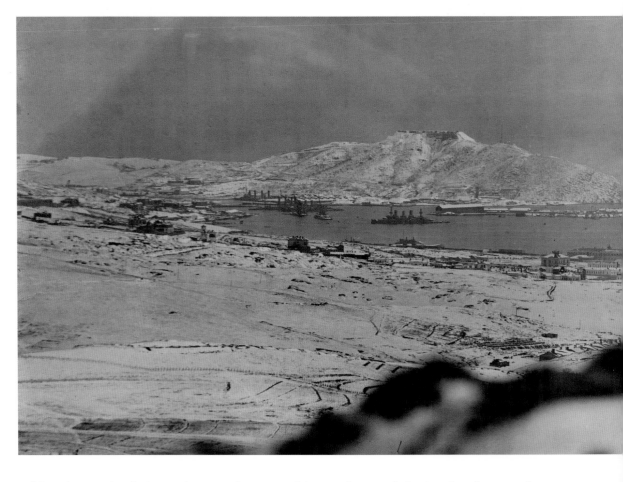

Unidentified photographer of the Mitsumura Toshimo Photographic Unit
Panoramic View of Port Arthur from
203 Meter Hill
Japanese photograph, December 18, 1904

achieved mass circulation and were published privately by his son as a *hibaihin* (article not for sale) in 1897, one year after his death. A copy of the two-volume, limited-edition album was presented to the imperial household.[7] The Army General Staff made some use of the one thousand or so negatives brought back by Lieutenant Toya and

his squad, commissioning the photographer and publisher Ogawa Kazumasa to publish a selection of photographs in albums of collotype prints and sets of lithographs during 1895. Albumen prints from the unit's negatives were also issued, apparently as a commercial undertaking. Whereas Bigot, armed with a snapshot camera, seemed to repre-

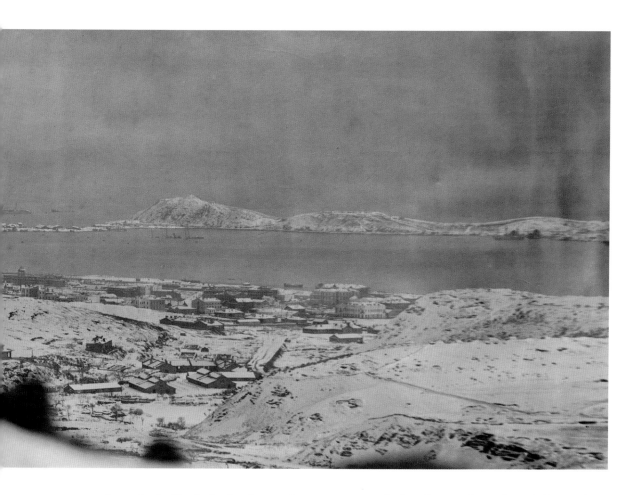

sent the arrival of both the freelance photographer and photography as a medium enjoying mass circulation and shaping popular opinion, and Count Kamei, with his adherence to the wet-plate process and his apparent amateurism, represented the final flowering of one current of Japanese photography, the work of Lieutenant Toya's squad of professionals, making full use of the dry-plate process and yet subject to official restraints in its choice of subject matter (or at least in what was selected for publication), represented the beginning of an age when photography was becoming an essential tool in shaping perceptions of Japan's war effort.[8]

Cover of The Russo-Japanese War: Taken by the Photographic Department of the Imperial Headquarters, *no. 1 (1904), published by K. Ogawa*

OPPOSITE
Ogura Kenji (1861–1946)
Japanese Dead on the Battlefield at Dashihqiao,
July 25, 1904
Japanese photograph published in The Russo-Japanese
War: Taken by the Photographic Department of the
Imperial Headquarters, *no. 1 (1904)*

PHOTOGRAPHY AND
THE RUSSO-JAPANESE WAR

The Russo-Japanese War saw the recall to active duty of the wartime Army Photographic Unit and this time Ogura was appointed its head. Although nominally part of the Imperial Headquarters, Ogura's unit was the result of extensive collaboration between himself and the photographer-publisher Ogawa, and it had a distinctly civilian, not to say commercial, aspect. Of the unit's eleven members, only two, Ogura and Yoshida Ichitarō, were employees of the Army General Staff, and although both were part of its Surveying Department, neither had military rank. The remaining nine members were either employees of Ogawa's photographic studio, the Gyokujunkan, or connected with it in some other way.

Ogura and the photographers in his charge took some five thousand negatives during the entire course of the war, and unlike the portfolio of the Sino-Japanese War where authorship remains unclear due to insufficient documentation, the work of the army photographers during the Russo-Japanese War can be clearly attributed.[9] Ogura was, without doubt, the most experienced of the army photographers, having received a baptism of fire during the Sino-Japanese War and having spent a year in Austria studying photographic printing developments at the behest of the Army Ministry in the interim between the two wars. The task of photographing grand maneuvers, which had fallen to his section in peacetime, also meant that he had received regular practice in photographing the Japanese army.

Ogura's work during the Russo-Japanese War varied according to the units to which he was assigned, for his duties soon took him away from headquarters and placed him with the Japanese Second, and later the Fourth Army. On occasion, Ogura was able to reach the frontline and brush up on his skill in dodging enemy shells. He also took some poignant battlefield studies that left little doubt of the human cost of the war. Whereas the official photographic record of the Sino-Japanese War had shown only the enemy dead, that of the Russo-Japanese War was remarkable in its inclusion of scenes with Japanese war dead, and the most memorable were taken by Ogura. One image of particular power shows the Japanese dead after the battle at Dashiqiao (Tashihchao) on July 25, 1904, lying in a rough line on a hillside, while the skyline above is dominated by the outline of a distant Japanese cavalry trooper standing beside his horse. The photographer created a strange sense of emptiness while hinting at the eventual victory.[10]

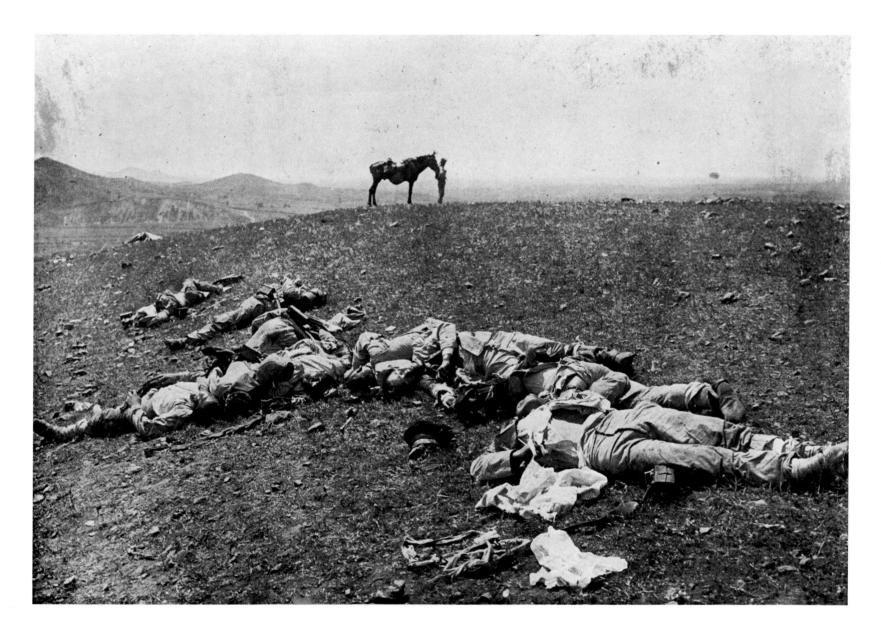

Yoshida Ichitarō (dates unknown)
Russian Prisoner-of-War with the Japanese Second
Army, July 3, 1904
Japanese photograph published in The Russo-Japanese
War: Taken by the Photographic Department of the
Imperial Headquarters, *no. 1 (1904)*

One year and one day after his battlefield study, Ogura took a photograph in complete contrast to this evocation of the pity of war. It became one of the most famous and widely circulated photographs of the Russo-Japanese conflict. Taken at Japanese army headquarters at Mukden on July 26, 1905, it was a group portrait of the senior members of the Japanese High Command. The chief of the Imperial Headquarters Staff, Marshal Yamagata Aritomo, was visiting the Manchurian theater of operations at this time. A special reception was held for him at Mukden, attended by the commanders of the five Japanese armies in the field—Generals Kuroki, Oku, Nogi, Nozu, and Kawamura, the local Chief of General Staff, General Kodama, and Marshal Ōyama Iwao (General Ōyama was appointed Field Marshal in 1889). This gathering of the top brass was a unique photo opportunity, and Ogura was given permission to bring his camera while the generals were enjoying their dinner. The evening light was fading fast, however, and Ogura found that it was simply too dark to photograph the party in the dining room. Still, he was reluctant to ask such high-ranking officers to move outside into the courtyard. Fortuitously, Ōyama stood up and left his place for an instant, and without a moment's hesitation, Ogura took the marshal's chair out into the courtyard and placed it against the wall. Ōyama returned

and took up his new place with good humor, and the other generals quickly followed suit, enabling Ogura to catch the remaining light of that day and photograph the group using a three-second exposure. The resulting group portrait, deferential and yet capturing the character of each sitter, was an instant success. Ogura's photograph, entitled *Nigensui rokutaishō* (Two Field Marshals, Six Generals), enjoyed wide circulation, appearing in the *Kokumin shinbun* on November 9, 1905, and on numerous postcards.

The other member of the army photographic unit who distinguished himself during the Russo-Japanese War was its oldest, Ōtsuka Tokuzaburō. Apart from the fact that he was born in 1853 to a samurai family of the Kuwana clan, nothing is known of the first three decades of Ōtsuka's life. Nevertheless, he appears to have acquired a reputation as a skilled photographer by his early thirties, for when Ogawa Kazumasa returned from his studies in the United States in 1884 and in the following year established his Gyokujunkan studio in Tokyo, he invited Ōtsuka to join his staff as senior photographer. It was evident that Ogawa, who was Ōtsuka's junior by some seven years, had great respect for Ōtsuka's knowledge of photography, which seems in some ways to have exceeded his own. In 1904, at Ogawa's request, Ōtsuka joined the Daihonei photographic unit headed by Ogura, but, in con-

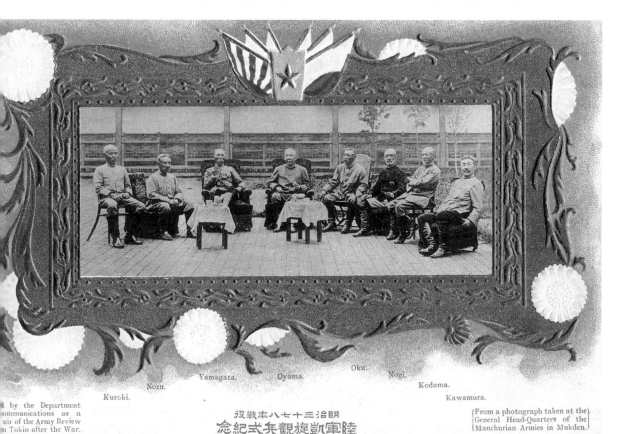

Postcard artist unknown
Original photograph by Ogura Kenji (1861–1946)
Official Commemoration Card: The General Headquarters of the Manchurian Armies in Mukden
Japanese postcard, 1906

Kuroki.
Nozu.
Yamagata.
Oyama.
Oku.
Nogi.
Kodama.
Kawamura.

by the Department
ommunications as a
nir of the Army Review
n Tokio after the War.

明治三十七八年戦役
陸軍凱旋観兵式紀念

(From a photograph taken at the)
(General Head-Quarters of the)
(Manchurian Armies in Mukden.)

sideration of his relatively advanced age (he was then fifty-one), Ōtsuka asked to be assigned to a theater of operations where the rigors of campaign would be less arduous than elsewhere on the Manchuria front. He specifically requested an attachment with the Japanese Third Army, commanded by General Nogi. At the time, this seemed a sensible choice—Nogi himself had been summoned from a leave of absence to command a force against Port Arthur, in what the Imperial General Staff believed would be a campaign of only slightly longer duration than that successfully conducted against the same stronghold ten years earlier, during the Sino-Japanese War. Events would prove both Ōtsuka and the Daihonei wildly optimistic. In the six years that Port Arthur had been in Russian hands, a network of concrete and steel fortifications had been constructed, and the campaign to reduce Port Arthur would be the most arduous of the

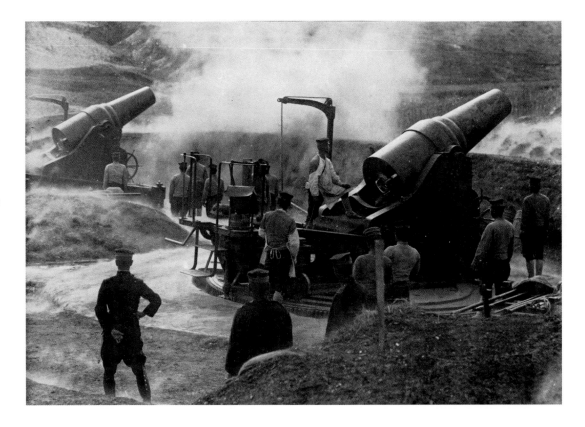

entire war. Anticipating a cozy billet, Ōtsuka instead found himself attending a bloody and hard-fought campaign. The siege of Port Arthur bore many of the hallmarks of what, little over ten years later, would be indelibly associated with the carnage of the First World War in Europe. In his photographic record of it, Ōtsuka succeeded not only in depicting the harbingers of modern warfare—trenches, heavy artillery, machine guns, and barbed wire—but also in evoking the desolation they wrought on the battle-field.

Another member of the army's photographic unit who should be mentioned in passing is Saitō Jirō, of whom nothing is known except that he was one of the civilian members of the unit and therefore connected with Ogawa, and that he spent the war attached to General Oku's Second Army. Saitō appears to have been drawn to the detritus of war, and many of his

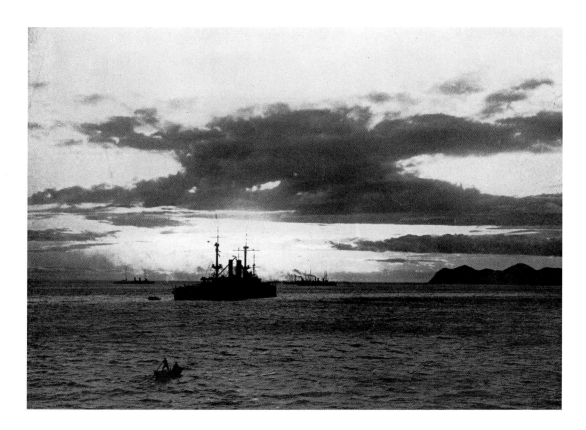

Seki Shigetada (1863–1945)
Sunset at a Naval Base
Japanese photograph published in The Russo-Japanese
War: Naval, *no. 1 (1904)*

photographs are remarkable in their depiction of objects left behind by the retreating Russian army, illustrating the conflict in an almost abstract way. One example, which was taken during the Japanese advance north, shows a pile of discarded field canteens glinting in the spring sun outside a deserted Russian communications depot.[11]

The naval side of the war is significantly less well documented. To photograph the war at sea, the Imperial Japanese Navy employed its own officers, especially those with some technical background. A typical example was Engineer Ichioka Tajirō, a former instructor at the Naval Academy who had just patented a new process for manufacturing smokeless gunpowder and who, during the war, recorded the navy preparing for action. Ichioka would later edit the officially sanctioned albums of the war at sea. Another technician, Chief

Engineer Seki Shigetada (1863–1945), provided what may have been the most comprehensive coverage of the naval war. Perhaps unique among the naval photographers of the Russo-Japanese War, Seki already had a track record as a photographer, with a published portfolio to his credit. While serving on the battleship *Asahi*, he created photographs that not only documented engagements against the Russian navy—in particular the Battle of Tsushima on May 28, 1905, and the effects of Japanese shell fire on captured enemy warships—but also transcended the war by depicting the Japanese navy in uneasy juxtaposition with the sea: his scenes range from moored warships silhouetted against a sunset to a storm viewed from the forecastle of a battleship blockading Port Arthur.[12] Other officers of the Japanese navy also contributed to the photographic record of the Russo-Japanese War, but none matched the skill of Seki and, to a lesser extent, Ichioka.[13]

The recruitment of photographic talent among its officer corps did not preclude the Japanese navy from giving permission to commercial photographic units to make their own visual record of the war at sea. One figure who worked closely with the navy, and who deserves greater recognition as a contributor to the photographic record of the Russo-Japanese War, is the Japanese photographer and entrepreneur Mitsumura Toshimo.[14] The son of a wealthy Kobe merchant, Mitsumura had the means and the connections by which to establish his own publishing enterprise, the Kansai Photographic Printing Company, in 1901. The outbreak of hostilities with Russia in 1904 found Mitsumura, only twenty-six years old, busy with various projects, including fine art color printing (he would win a gold medal at the Saint Louis World's Fair later that year for his reproduction of one of Japan's national treasures, the Heian-era scroll painting of Kujaku Myōō) and postcard printing, which was booming since the law had been changed in 1900 to allow the private production of postcards. Nevertheless, Mitsumura responded quickly to the opportunities presented by the war and assembled a photographic unit to accompany Japanese forces. Before he had even received permission from the Navy Ministry, Mitsumura took passage on the navy transport vessel *Manshūmaru* after pulling strings with his friend Captain Takarabe Takeshi, who was serving on the Naval General Staff. The *Manshūmaru* took foreign correspondents and military and naval attachés on a tour of Korea and those areas in Manchuria already under Japanese occupation, but it gave them little opportunity to observe—and Mitsumura's unit little chance to record—much of the

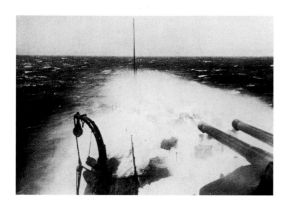

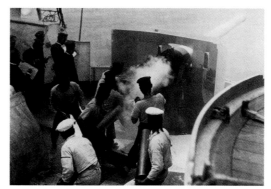

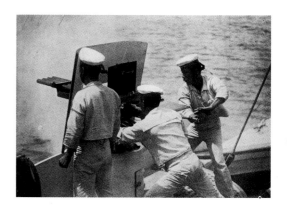

war. Still, Mitsumura's photographs from the voyage were later printed as a collotype album entitled *Manshūmaru junyū kinenchō* (Commemorative Album of the Tour of the *Manshūmaru*), which the navy minister gave away as presents to its disappointed foreign guests.

In October 1904, the Mitsumura unit finally got its opportunity to accompany Japanese forces at the front when it was given permission to proceed to Manchuria. It is unclear whether Mitsumura accompanied the unit himself or left it in the charge of his chief photographer, Nogami Yoshio, whose portfolio had hitherto consisted of photographic studies of cherry blossoms.[15] Although nominally assigned to the navy, the unit was allowed to accompany Nogi's Third Army to the front line and recorded the ferocious assault on Port Arthur, in particular the struggle for 203 Meter Hill, which overlooked the enemy harbor. The army

made frequent requests to Mitsumura's unit, commissioning detailed photographs of the interior of Port Arthur from the summit of 203 Meter Hill, as well as instantaneous photographs of the bombardments and mining operations that eventually led to the Russian surrender on January 1, 1905. When General Nogi and the Russian commander General Stoessel met four days later to discuss terms, the Mitsumura unit was present to take a commemorative group portrait of the two generals and their staffs. This photograph, perhaps more than any other taken before or during the war, came to represent Japan's victory over Russia and would be reproduced in almost every mass medium of the day.

Astonishingly, it appears that the Mitsumura unit photographers were unable to appreciate their own work until they returned to Japan, which they did with great speed. Arriving home on January 27,

LEFT
Seki Shigetada (1863–1945)
The Main Battleship Squadron Blockading Port Arthur in Stormy Weather
Japanese photograph published in The Russo-Japanese War: Naval, *no. 1 (1904)*

MIDDLE
Ichioka Tajirō (dates unknown)
Firing a Six-Inch Quick-Firing Gun
Japanese photograph published in The Russo-Japanese War: Naval, *no. 1 (1904)*

RIGHT
Ichioka Tajirō (dates unknown)
Firing a Nordenfeldt Machine Gun
Japanese photograph published in The Russo-Japanese War: Naval, *no. 1 (1904)*

MEMORABLE MEETING OF GENERALS NOGI AND STOESSEL
AT SUISHIYING PHOTOGRAPHED AFTER LUNCHEON ON THE 5TH, JAN, 1905.
Снимка гг. Ноги и Стесселя, после обеда, по случаю передачи крепости
Портъ-Артура.

they finally were able to develop and take prints from their precious plates in a special facility assigned to them at the Imperial Naval Staff College in Tokyo. The Imperial Household and the Navy Ministry each received an album of photographs selected by Mitsumura from his unit's Port Arthur portfolio. Mitsumura enjoyed commercial success, especially in his home area of Kansai, with collotype albums and postcards depicting the siege and the surrender. The Mitsumura unit made at least one further photographic tour to the front line and was one of the few units (with the exception of the army's own photography unit) to join the army on its northbound expedition to Sakhalin in July 1905, the only occasion during the war when Japanese forces

Postcard artist unknown
Original photograph by an unidentified photographer of the Mitsumura Toshimo Photographic Unit
Memorable Meeting of Generals Nogi and Stoessel after the Fall of Port Arthur at Shuishiying Photographed after Luncheon on January 5, 1905
Japanese postcard, 1905

RIGHT
Unidentified photographer of the Mitsumura Toshimo Photographic Unit
Generals Stoessel and Nogi
Japanese photograph, taken January 5, printed after January 27, 1905

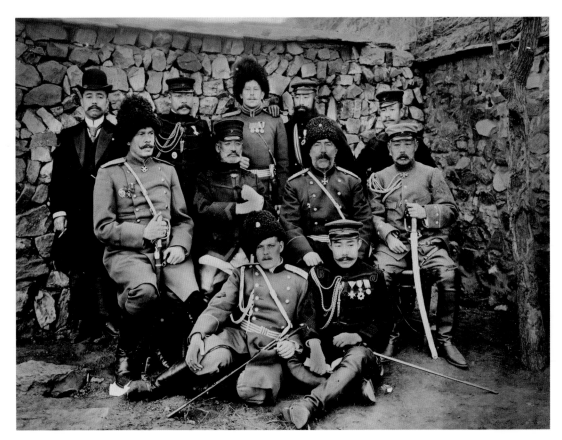

entered the Russian Empire proper (as opposed to Port Arthur, which was leasehold territory).[16]

Aside from such officially accredited photographers with the Japanese armed forces, the comparative ease of taking photographs in the field ensured that the photographic record of the Russo-Japanese War was also open to anyone armed with a portable camera. Many journalists took cameras with them on their assignments, and some were even in a position to accomplish minor scoops as the action unfolded on the Manchurian front. In addition, fortuitously, the Russo-Japanese War had broken out at a time when Japanese newspaper publishers were starting to master the technique of printing photographs as part of a paper's main issue, rather than as a special supplement, as had been the case during the Sino-Japanese War. The first such example had appeared on January 1, 1904, when as a New Year's feature the *Hōchi shinbun* published a page of portraits of celebrated Japanese women of the day. Following the outbreak of the war in February, other newspapers sought to publish photographs, though the main problem then was the availability of images connected with the conflict, rather than the technical means by which to reproduce them. In April 1904, the *Yomiuri shinbun* printed a prewar view of Vladivostok as part of a description of the

Russian naval base there, and the *Tokyo nichi nichi shinbun* printed portraits of Japanese war heroes. The first photographic image of the Russo-Japanese War to be printed in a Japanese newspaper as part of a feature article and, in fact, the first war photo to achieve mass circulation in a Japanese daily publication was taken by the journalist Ueno Iwatarō for the *Tokyo Asahi shinbun*. Ueno's view of an enemy trench occupied by Japanese troops during the Battle of Liaoyang was taken on September 1, 1904; more than four weeks later, it appeared in the *Asahi*'s September 30, 1904, issue. More of Ueno's photographs from the front would appear on the *Asahi*'s cover on an almost daily basis until the middle of October.[17]

Photographic magazines, which had proven popular during the Sino-Japanese War, enjoyed even greater popularity during the Russo-Japanese War, and the sheer number of them that appeared in the first few weeks of the conflict was remarkable. The *Japan Weekly Mail* reported on April 16, 1904:

It is a distinguishing feature of the Russo-Japanese War that although the struggle is still in its early stages, quite a mass of comparatively permanent literature has already been published with reference to its progress. By comparatively permanent literature we mean magazines and periodicals devoted solely to

recording the events of the conflict and compiled from maturer sources of information that [sic] *those accessible to the daily newspaper.*[18]

Foremost in the creation of "comparatively permanent literature" on the Russo-Japanese War was the Tokyo publishing house Hakubunkan. Many of the photographers and publishers involved in creating and distributing a visual record of the Russo-Japanese War were larger-than-life figures, and Hakubunkan, which produced some of the most popular pictorial magazines and collotype albums of the war, was founded by one such figure, Ōhashi Sahei. From its establishment in 1886, Hakubunkan was the focus of Ōhashi's publishing empire, and he worked as assiduously on cultivating his own legend as on expanding his considerable business interests. During a visit to the 1893 World's Fair in Chicago, Ōhashi held court before the American press corps, feeding them with exaggerated claims to being Japan's most influential publisher: he boasted that Hakubunkan published an average of two new book titles each day; he claimed that his publishing companies consumed one-third of all the Western paper used in Japan; and he presented himself as a cultural patron who was responsible for providing ordinary Japanese with a wide range of worthwhile reading matter at an affordable price. At home, Ōhashi was no more

modest. He was fond of describing the changes he had initiated in Japan's nascent magazine industry as the "Second Meiji Restoration," and a later company slogan trumpeted that Hakubunkan had done more for education in Japan than even the Ministry of Education. Unfortunately, Ōhashi died in 1901, but the company followed his guiding philosophy, and, despite its founder's absence, Hakubunkan was no less forward in capitalizing on the public interest in the Russo-Japanese War than it had been ten years earlier during the Sino-Japanese War. An official historian of the company later noted in connection with the company's remarkable commercial success in the Meiji era, "the Hakubunkan enterprise was indeed blessed with the good fortune of many wars."[19]

A mere ten days after Japan's formal declaration of war on Russia on February 10, 1904, Hakubunkan's first magazine of the Russo-Japanese War, *Nichiro sensō jikki* (True Record of the Russo-Japanese War), appeared for sale.[20] The title harkened to the *Nisshin sensō jikki* (True Record of the Sino-Japanese War), which had proven so popular ten years earlier, and space was made for it in an already crowded stable of Hakubunkan magazines by removing one of its less popular periodicals, *Jichi kikan kōmin no tomo* (The Local Governing Body and Citizens' Friend), which had been founded in

January 1903. This inspired recycling of the Hakubunkan line enjoyed instant success, with the first issue going into twenty-six printings (more than one hundred thousand copies); successive issues, which appeared three times each month, proved equally popular. The magazine's success owed much to its use of illustrations and photographs (its correspondents at the front, including the novelist Tayama Katai, were all encouraged to take photographs for the magazine), as well as war reports, and with each issue consisting of an average of 120 pages, it made for a substantial periodical. Its managing editor, Oshikawa Shunrō, was an up-and-coming young author of adventure stories, and in April 1904 he took advantage of the winning formula by establishing a companion magazine, *Nichiro sensō shashin gahō* (The Russo-Japanese War Photographic Pictorial), billing it as a "regular extra issue" of the *Nichiro sensō jikki*. Slightly larger, but also slightly slimmer than its companion, the monthly magazine ran to approximately sixty pages, about forty of which consisted of photogravures. It proved just as popular as its stable companion; so great was the demand that the first issue of the magazine went through more than ten printings. It outlasted the war, continuing in various reincarnations until 1908.[21]

Hakubunkan's success inspired imitators among rival publishers. Even before the

Nichiro sensō jikki saw the light of day, the publisher of the magazine *Jitsugyō no Nihon* (Entrepreneur's Japan) put a special issue entitled *Seirō senpō* (News from the War with Russia) on sale on February 17, 1904. In the following month, the Jitsugyō no Nihon Company established the magazine as an independent, trimonthly periodical, and in August it established a monthly magazine called *Seiro shashin gachō* (Photographic Album of the War with Russia) in further imitation of the Hakubunkan formula. With its own team of correspondents and photographers on the front line, the company was able to keep both periodicals going until after the end of the war. Another noteworthy competitor was Keigyōsha, who followed the same formula of renaming an existing periodical, in its case, the *Kinji gahō* (Contemporary Pictorial), which appeared under its new title of *Senji gahō* (Wartime Pictorial) on February 21, hot on the heels of Hakubunkan's *Nichiro sensō jikki*, which had appeared the day before. *Senji gahō's* editor, the famous author and poet Kunikita Doppō, also gave it a distinctive masthead in English, the *Japanese Graphic*. The title, as well as a larger-than-average size (11¾ × 9 inches) and the extensive use of photography, may have been intended to invite comparison with the London magazine the *Graphic* and other pictorial periodicals. In a market crowded with trimonthly magazines

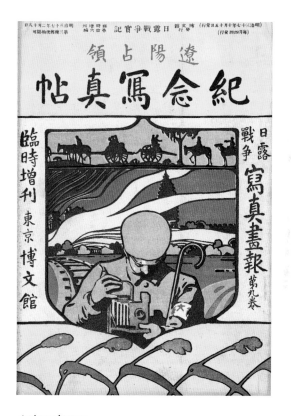

Artist unknown
Cover for Nichiro sensō shashin gahō *(The Russo-Japanese War Photographic Pictorial)*
Japanese lithograph, October 15, 1904

devoted to the war, the *Senji gahō* also managed to outlast the fighting, and after reverting to its prewar title in October 1905, it continued publication until 1907.

Competition between magazine publishers for well-taken photographs was fierce, and there appear to have been several photographers attached to the Japanese army on this basis alone. It is interesting, however, to see how relatively few there were. We know of one photographer, Enami Nobukuni, who was attached to the Japanese Second Army and represented the publisher of *Jitsugyō no Nihon*. Enami was a professional photographer of some experience and operated a studio in Yokohama, but little else is known about him, and his activities during the Russo-Japanese War remain undocumented. Other professional photographers whose activities as accredited photographers with the Japanese army still await investigation include Kaneda Hideo, who is known to have accompanied the Third Army during 1905; Matsunaga Gakurō, who was present during the Battle of Nanshan; and Ashino Keizaburō. Matsunaga later enjoyed the distinction of having his photographs of the conflict presented to the Imperial Household by Tanuma Taisaemon, a Yokohama businessman.

The large number of photographically illustrated magazines published during the Russo-Japanese War did present some serious competition to Hakubunkan, but when considered alongside the range of other activities in which the company was engaged during the war, including the production of postcards, the publication of collotype photograph albums, and, as we shall see, the creation of documentary films of the war by a special cinematographic unit, it was evident that the spirit of Ōhashi Sahei lived on and that Hakubunkan was destined to play a significant role in shaping public perception of the conflict.

"MOVING PHOTOGRAPHS"

One aspect of the visual record of the Russo-Japanese War that has received little attention is the role of early cinema in disseminating images. The distinction between photography and cinema may seem clear-cut today, but in its early days it was possible to regard cinema as very much an offshoot of photography, as the contemporary Japanese coinage for motion pictures, *katsudō shashin*, or "moving photographs," suggests. Unfortunately, very few of the film shorts taken during the Russo-Japanese War by either Japanese or foreign cinematographers appear to have survived, and most are known only through contemporary reports or advertisements.

What makes the early film footage of the Russo-Japanese War that has survived par-

ticularly interesting is that in Japan, at least, the role of *katsudō shashin* was viewed as much educational as entertaining, and when occasion demanded, edifying. The writer Lafcadio Hearn wrote to a friend in 1900 describing his visit to a Tokyo cinema where scenes of the South African War were being "shadowed by the cinematograph":

The representation was managed so as to create only sympathy for the Boers: and I acknowledge that it made my heart jump several times. The Boer girls and wives were displayed as shooting and being shot. What you would have enjoyed were the little discourses in Japanese, uttered between each exhibition. They were simple and appealed to Japanese sympathy—to the sense of patriotism, and the duty of dying to the last man, woman and child for one's country.[22]

Unfortunately Hearn seems never to have repeated the experience before his death in 1904, and posterity is deprived of his comments on Japanese-made film shorts on the Boxer Rebellion and the Russo-Japanese War.

The Russo-Japanese War would be covered by at least four Japanese cinematographic units, dispatched by the companies Hakubunkan, Yoshizawa Shōten, Yokota Shōkai, and Hiromeya. The Tokyo firm of Yoshizawa Shōten is an interesting example of a company shifting from one medium to another; ten years earlier, it had been a small enterprise in the Ginza, exporting Japanese woodblock prints to the West. By 1904, however, it was already well established as a producer of documentary film, having sent a unit to China in 1900 to take footage of the Boxer Rebellion. Despite Hakubunkan having just poached Shibata Tsunekichi, its senior technician, the Yoshizawa Shōten unit was up to full strength, and its members were enthusiastic. Indeed, two of its technicians, Kuboi Shinichi and Itō Kyūtarō, proved so enthusiastic in their search for fresh footage of the war that they got ahead of the Japanese advance line during the Battle of Liaoyang and were caught behind Russian lines. (They would spend the rest of the war in Russian captivity.)

Hiromeya was another major Japanese producer of film shorts. Originally established in 1888 as an advertising agency, the firm had set up a film department in 1896 to promote foreign-made reels, but by 1899 it was making its own short films. The Yokota Brothers of Kyoto, Einosuke and Masunosuke, were also early exponents of cinematography, having originally acquired performing rights in Japan, some film shorts, and projecting equipment from their friend Inabata Katsutarō. In 1897, Inabata had been the first Japanese to invest in

Auguste and Louis Lumière's invention. Hakubunkan's creation of a special film unit during the Russo-Japanese War was a reflection of the company's ambition to capitalize on every new development in the mass media.[23]

It is difficult to establish how many films were created from 1904 to 1905 that related to the Russo-Japanese War, especially since so few have survived. The output of the Yoshizawa Shōten unit alone has been esti-

mated at forty-eight short newsreels, and one Japanese source has noted that more than 270 films of the war were produced. Such estimates do not always distinguish between *jissha*, or authentic documentary film footage, and reconstructions of the war created far from the front.

Some films advertised as depicting the war were not even from the Russo-Japanese War. Certain cynical impresarios found that for a time they could get away with passing

Photographer unknown
Members of the Yoshizawa Shōten Cinematographic Unit, Shortly after Their Capture during the Battle of Liaoyang, 1904
Russian photograph, published in an album of photogravures about 1906

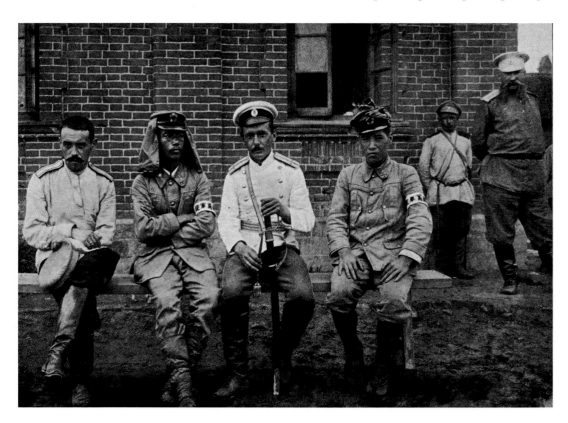

off earlier imported film shorts of the Spanish-American War and the Boer War as records of the war in Manchuria. In other instances of public deception, some films advertised as depicting the war were not even films. The Kabukiza, for example, which found itself losing ground to katsudō shashin during the Russo-Japanese War in the same way that it had been supplanted by the more realistic *shinpa* theater during the Sino-Japanese War, made a brazen attempt to cash in on the vogue for cinematography by unveiling a so-called Kineorama of the Russo-Japanese War at the Kabukiza on June 24, 1905. It was a far cry from the original Cineorama projection process patented in France seven years earlier (but never realized), whereby, in a forerunner of today's multiplex cinema, ten simultaneous films were supposed to be projected side by side onto a large panoramic screen. Visitors to the Kabukiza were treated instead to the spectacle of a six-inch-deep large tank filled with water, behind which was displayed a crudely painted backdrop. A contemporary newspaper account, saturated with the author's disapproval of such "a ridiculous spectacle hardly worthy of comment," describes how three scenes from the war were crudely re-created before a gullible audience. In the first, lasting about fifteen minutes, the center of Port Arthur was re-created with model buildings placed between the water tank and the backdrop; water was poured down through an overhead draining board, and the sound of thunder was simulated offstage to give the effect of a storm. The lights were cut, and a light shone from the side to imitate the last rays of the setting sun, with the reviewer snorting, "beautiful though it may be, this is hardly anything special in this day and age." The second scene, some ten minutes in length, reproduced the destruction of the citadel through a judicious combination of red light and firecrackers (supported by noises offstage), which had the immediate effect of reducing the entire audience to a prolonged bout of coughing as a pall of smoke from the firecrackers drifted into the auditorium. Model ships measuring some eighteen inches in length represented the belligerent navies. The final scene purported to show the Battle of the Japan Sea; the water tank was used to full effect, with a rising sun revealing the Russian fleet—conveniently deployed in a single row—being sunk by a pocket-size Japanese navy. Despite the obvious shortcomings of the spectacle, it enjoyed some popularity, and the *Yorozu chōhō* reported with evident bemusement that before the opening, "the space in front of the Kabukiza is thick with people, all of whom have descended from the line of streetcars that stopped there."[24]

Despite the extensive production and screening of real and bogus films of the war,

their relatively short length (each reel lasted at most a few minutes) seems to have necessitated some padding out of the program on the part of theater owners before they felt they could ask their audiences to pay the relatively high ticket prices (the average price of admission at that time was 50 sen, compared with the 20 sen it cost to buy an issue of Hakubunkan's *Nichiro sensō shashin gahō*). The result was a strange mixture of edification and entertainment. During the first week of May 1904, the Kinkikan theater in Tokyo featured a curious billing entitled *Nichiro sensō katsudō daishashin* (Great Moving Photographs of the Russo-Japanese War), which included not only footage of the Manchurian and home fronts, such as *Occupation of the Vicinity of* Blank *(Name Withheld for Reasons of National Security), Amateur Sumo Wrestling at Our Army's Camp at* Blank, and *The Funeral of Commander Hirose*, but also film taken through a microscope showing the growth of the typhus virus ("enlarged to between 45,000,000 and 75,000,000 times its natural size," according to one newspaper report). The Kabukiza, properly acknowledging the popularity of the new medium, showed an even more eclectic selection of reels in addition to such wartime fare as *Injured Enemy Soldiers Being Treated by the Japanese Red Cross, The Attack and Occupation of the Fortifications at Nanshan*, and *The Departure of General Ōyama from Shinbashi for the Front*. The longest piece in the billing was a film entitled *The Shipwreck of Robinson Crusoe*, and of the other entertainments, the content appears to have covered a broad range; *A Tale of Descent and Destruction Brought About by Poor Examination Results, The Haunted House in the Ruins of Napoleon's Palace*, and *Curious Acrobatics with Items of Clothing* remain the most eyecatching, though shorts such as *Scenes of the Trawling and Canning of Fish on the Island of Sakhalin* and *A Parade of Large Elephants* leave less to the imagination.

The main message was not forgotten, however, and *benshi*, or narrators, whose job it was to explain to audiences what they were witnessing, found that the Russo-Japanese War transformed their rather peculiar profession into something close to a patriotic calling. Some used the popularity of war footage as an opportunity to hone their oratorical skills and acquired a loyal following in the process. One *benshi*, Hanai Hideo, gave his wartime performances wearing a quasi-military uniform; he lacked only a sword, it seems, to pass for an officer of the Imperial Army. When the police accused him of being disrespectful to the national uniform and ordered him not to wear such an outfit in the future, Hanai succeeded in convincing them that no disrespect was intended and that he was

merely displaying his patriotism. Hanai shocked his audiences by punctuating his explanations with cries of "Stand up! Hats off!" during the more stirring scenes, but any would-be critics were soon won over when entirely unfounded rumors circulated that he had served in Manchuria and had returned to Japan after being wounded in action against the Russians.

A script delivered by an unidentified *benshi* before a Kobe audience in June 1905 has survived and is worth quoting in full to give some idea of what an early Japanese cinemagoer would be regaled with toward the end of the Russo-Japanese War.

> *Everybody! Everybody in this entire audience! As you all know, in the current combat with Russia, since the outbreak of the war, we have won every battle, from the Liaodong Peninsula to the fall of Port Arthur, to the occupation of Mukden, to the great naval battle in the sea of Japan . . . which resulted in the annihilation of their Baltic fleet. That resounding victory was unprecedented and unparalleled throughout world history. There is nothing to say except "Banzai!" for the Empire! For world peace and the benefit of both Japan and Russia, His Excellency, President Roosevelt of the United States of America, defined the terms of peace negotiations. Plenipotentiaries of both Japan and Russia will begin peace negotiations at an early date in Washington*

> *D.C. [sic] the capital of the United States of America. Everyone, listen to me! If the truth be told, Russia is an unprepared country; however, if we are careless, we will be taken in by their tricks and the consequences will be dire. Since we do not know whether or not the upcoming peace negotiations will end successfully, our nation must be increasingly militarily prepared, while we as a nation must thoroughly cultivate our patriotism. When His Imperial Majesty calls, we, his subjects, must be prepared to exhaust ourselves completely. In order to understand this preparation, it may be useful to watch motion pictures about our frontline soldiers, who fight hard, without concern for their homes nor themselves, but only this nation. These motion pictures are different from the eight hundred hackneyed lies that charlatan showmen try to pass off. So please keep that in mind as you watch. Furthermore, in the scenes where you see our soldiers attack, I want you all to shout out "Banzai!" to cheer them on. First, we shall show you Pursuit Battle at Mukden.[25]*

It is not too difficult to imagine the combined effect on an audience of this kind of patriotic exhortation followed by a *katsudō shashin* showing the troops at the front, and it may serve as an extreme example of how one aspect of the photographic medium could be called upon to support Japan's war effort. Perhaps it is not so extreme an exam-

ple: the end of the Russo-Japanese War provides a more troubling illustration of how photography could be used to serve the state. On September 5, 1905, a mass rally held in Hibiya Park, in Tokyo, to protest the terms of the peace being concluded with Russia turned violent, and a riot broke out across the city resulting in widespread destruction of property, injury, and even several deaths. A local photographer, Takagi Masutarō, took pictures of the rioting from the roof of the Supreme Court, probably with the intention of simply documenting the event. When, however, the perpetrators of the riot were put on trial, Takagi's photographs were subpoenaed and used as evidence against them by the state.

The Hibiya Park riot is perhaps an appropriate place to end this story. Photographic imagery of the war with Russia did much not only to create a sense of the invincibility of Japan's armed forces but also to illustrate the extent of the enormous loss of life re-

quired to achieve this success. One reason the riots took place was that the Japanese public had been presented with a credible image of victory and, unlike the Japanese negotiating party at Portsmouth, New Hampshire, was unaware of how precarious Japan's true position was. Thus, when the terms of the treaty with Russia were announced, initial shock at the government's apparent yielding to Russian demands soon gave way to outrage and violence. The development of Japanese photography during the Russo-Japanese War is therefore more than just an illustration of how technical advances made it possible for instantaneous photographic images of the conflict to be reproduced and distributed in a variety of formats unimaginable ten years earlier. It also reflects that photography, thanks to its perceived authenticity, could be called upon to serve a nation's war effort and create, for good or ill, an image of shared sacrifice and success.

1. See Iwashita Tetsusuke, "Tokugawa Yoshikatsu no shashin kenkyū to satsuei shashin," pts. 1 and 2, *Kinko sōsho: Shigaku bijutsushi ronbunshū* (Tokyo: Tokugawa Reimeikai) 18 (1991): 223–85; 19 (1992): 219–59. For a general introduction to the documentation of conflict by Japanese photographers, see Ozawa Takeshi, ed., *Shashin: Meiji no sensō* (Tokyo: Chikuma Shobō, 2001).

2. Tokugawa Yoshikatsu's photographic endeavors, although in no way comparable, coincided with those of Felice Beato, an established European war photographer who had made his home in Japan the year before and was accompanying a Western punitive expedition (also against the Chōshū clan) that resulted in the first known images of conflict taken in Japan.

3. Matsuzaki and Kumagai's portfolio was advertised, specifically, as nineteen *ōhan* (large plate) and twenty *koban* (small plate, presumably carte-de-visite format) prints. The photo-historian Morita Mineko has been undertaking an extensive search in Japanese institutional and private collections for the photographs of the Taiwan Expedition but has not yet found any images that can be attributed to Matsuzaki and Kumagai with any certainty. Western sources continue to assert that Kumagai was killed by a stray bullet. However, extensive research by Morita, based largely on Matsuzaki's manuscript diary of the campaign, has established that Kumagai met a less heroic end in a field hospital after contracting malaria. Morita Mineko, *Nakahashi Izumichō Matsuzaki Shinji shashinjo: Oyatoi shashinshi, sensō, tantei, hakurankai wo yuku* (Tokyo: Asahi Shinbunsha, 2002), 39.

4. See Professor Ishikawa Hiroo's essay "Seinan sensō no shashin," in *Shashin*, ed. Ozawa, 11–16.

5. Kamei's privately funded photographic unit consisted of himself, Miyazaki Sachimaro, Arata Mannosuke, Hashimoto Bunzō, Morigane Jirōemon, and Nakanishi Keijirō. According to Izakura and Boyd, Nakanishi (1869–1911), a Tokyo-based photographer, appears to be the only member of the group to have had any commercial, or indeed professional, experience. See Izakura Naomi and Torin Boyd, *Sepia iro no shōzō: Bakumatsu Meiji meishiban shashin korekushon / Portraits in Sepia from the Japanese Carte-de-Visite Collection of Torin Boyd and Naomi Izakura* (Tokyo: Asahi Sonorama, 2000).

6. T. E. Holland, "International Law in the War between Japan and China," *Fortnightly Review* (June 1895), quoted in Mutsu Munemitsu's *Kenkenroku: A Diplomatic Record of the Sino-Japanese War, 1894–1895*, ed. George Lensen (Princeton, N.J.: Princeton University Press, 1982), 75.

7. A selection of Kamei's photographs from the album *Meiji nijūshichihachinen seneki shashinchō*, together with a facsimile of his published diary, was reprinted in 1992. See *Kamei Koreaki: Nisshin sensō jūgun shashinchō hakushaku Kamei Koreaki no nikki* (Tokyo: Kashiwa Shobō, 1992).

8. Among the commercial photographers known to have accompanied the Japanese army during the Sino-Japanese War are the Nagoya photographer Suzuki Keikun, who was present during the Battle of P'yŏng'yang; Endō Rikurō, who was attached to General Nogi's Second Division; and Asai Kaiichi, who appears to have submitted photographs to the Tokyo *Asahi shinbun* that were reproduced by the newspaper in a special supplement. Endō published an album of his photographs in his hometown of Sendai in November 1895. See Nihon Shashin Kyōkai, ed., *Nihon shashinshi nenpyō, 1778–1975.9* (Tokyo: Kōdansha, 1976), 109.

9. The members of the Imperial Headquarters

Shashinhan, listed according to their attachments during the Russo-Japanese War, were as follows: Ogura Kenji (chief photographer, attached to the General Headquarters of the Manchurian Army, with additional responsibility for the Second and Fourth Armies), Tabuchi Jirōkichi (First Army), Morigane Shūgaku (First, and later Third and Fourth, Army), Yamazaki Eikizō (First, and later Second, Army), Yoshida Ichitarō (First, and later Second and Third, Army), Kobata Shirō (Second Army), Saitō Jirō (Second Army), Hosaka Kōtarō (Second, and later Third, Army), Asai Kaiichi (Third Army), Ōtsuka Tokuzaburō (Third Army), and Nakamura Kōsaku (Fourth Army).

10. This photograph was selected by the camera researcher Sakai Shūichi as the most representative image of the Russo-Japanese War taken by the army photographic unit. See Sakai Shūichi, "Ogawa Kazumasa to Ogura Kenji—Nichiro sensō no dai-honei shashinhan," in *Shasin*, ed. Ozawa, 132.

11. See also Kinoshita Naoyuki, *Nihon no shashinka*, vol. 2, *Tamoto Kenzō to Meiji no shashinkatachi* (Tokyo: Iwanami shoten, 1999), plate 41, for a reproduction of Saito's photograph.

12. A collotype album of photographs taken by Seki illustrating the voyage made by the warships *Asama* and *Takasago* to England to participate in King Edward VII's Coronation Review, *Toei no omokage* (Kobe: Nakao Shintarō), was published in 1903. Seki's portfolio from the Russo-Japanese War can now be evaluated in detail thanks to the recent reprinting of his privately produced portfolio *Seiro kaisen shashinchō* (Album of Photographs of the Naval War against Russia). See Todaka Kazushige, ed., *Gokuhi: Nichiro kaisen shashinchō* (Tokyo: Kashiwa shobō, 2004). According to the Nihon Shashin Kyōkai, ed., *Nihon shashinshi nenpyō*, 124, an album of one hundred collotypes by Seki

entitled *Asahi no hikari* was published by Hakubunkan in 1905. This album was a record of the war at sea, and in particular the Battle of Tsushima, as experienced on the battleship *Asahi*. Unfortunately, I was unable to examine both this and Seki's earlier album *Toei no omokage*, held in the National Diet Library in Tokyo, before this essay went to press.

13. The Naval Department issued a selection of 117 photographic plates in four volumes during 1905. See Ichioka Tajirō, ed., *Nichiro seneki kaigun shashin-chō*, vols. 1–4 (Tokyo: Ogawa Kazumasa Shuppanbu, 1905). Of the sixty-nine photographs bearing detailed credits, twenty-four were by Ichioka and fifteen by Seki. Among the eight other contributors were a naval instructor by the name of Ashino, who recorded the Battle of the Yellow Sea, and Lieutenant Miyake, whose photographs show the Japanese navy patrolling the icebound waters north of Hokkaidō.

14. The only biography of Mitsumura is Masuo Nobuyuki's, *Mitsumura Toshimo den* (Tokyo: Mitsumura Toshiyuki, 1964). For an overview of his career, see Sasaki Toyoaki, "Ōsaka no shashin daijin: Mitsumura Toshimo," *Ōsaka Shunshū* 51 (November 24, 1987): 38–44.

15. See Nogami Yoshio, *Sakuragari* (Osaka: Kansai Shashin Seihan Insatsu, 1902). A copy of this rare collotype album is held in the National Diet Library, Tokyo.

16. Curiously, no photographs of the Sakhalin (or Karafuto) Expedition were published by Mitsumura's company, although he produced at least four collotype albums of photographs of the siege of Port Arthur during 1905. One possible explanation is that he may have come to some agreement with Hakubunkan, which had already published an album of his Port Arthur portfolio that year.

17. For a brief discussion of the connection between early war photography and Japanese newspapers, see Matsumoto Itsuya, "Shinbun no sensō shashin," in *Shashin*, ed. Ozawa, 120–22.

18. *Japan Weekly Mail*, April 16, 1904, 434.

19. See Giles Richter, "Entrepreneurship and Culture: The Hakubunkan Publishing Empire in Meiji Japan," in *New Directions in the Study of Meiji Japan*, ed. Helen Hardacre and Adam L. Kern (Leiden: Brill, 1997), 590–602.

20. As Professor Kōno has pointed out, the official biography of the Hakubunkan founder, Ōhashi Sahei, made the spurious claim that the *Nichiro sensō jikki* first saw the light of day on February 13, 1904. Kōno Kensuke, "Nichiro sensōka no zasshi kara (2)," *Nippon kosho tsūshin* 69, no. 2 (February 16, 2004): 1.

21. The *Nichiro sensō shashin gahō* was renamed the *Shashin gahō* (Photographic Pictorial) in January 1906, and it continued in this guise until 1908, when, in a complete change of editorial direction, it was renamed *Bōken sekai* (World of Adventure).

22. Osman Edwards, "Some Unpublished Letters of Lafcadio Hearn," *Transactions and Proceedings of the Japan Society* 16 (1918): 23.

23. Eight members of the wartime *katsudō shashin* units are credited in the standard reference work on early Japanese films as follows (listed according to organizational affiliation): Shibata Tsunekichi (head of the Hakubunkan unit); Fujiwara Kōzaburō, Shimizu Kumejirō, Kitabatake Tadao, Kuboi Shinichi, and Itō Kyūtarō (Yoshizawa Shōten); Mizushima Tadao and Mayota Iwao (described as members of the Photographic Unit Accompanying the Left Wing of the Army; it is unclear whether they were employed by the Yokota Brothers or Hiromeya). The total number of Japanese cinematographers with the army could easily be a multiple of this figure; it is known that the Hiromeya unit employed five or six technicians, and if the same numbers were deployed by the three other units (Shibata cannot have been the sole representative of Hakubunkan on the Manchurian front, for example), there may have been as many as twenty-four.

Of the cinematographers known to have covered the Russo-Japanese War, only two subsequently made a name for themselves in Japan's nascent film industry. Shibata was perhaps the most successful and directed several film dramas before his death in 1929; Fujiwara would prove even more prolific, directing some silent films, including a 1918 dramatization of General Nogi's life wistfully entitled *Nogi Shōgun, Aa Nogi Shōgun*. See Nihon Eigashi Kenkyūkai, ed., *Nihon eiga sakuhin jiten: Senzenhen* (Tokyo: Kagaku Shoin, 1996).

24. *Yorozu chōhō*, June 27, 1905, quoted in *Nyūsu de ou: Meiji Nihon hakkutsu*, ed. Suzuki Kōichi (Tokyo: Kawade Shobō Shinsha, 1995), 7:230. Despite its dubious claim to a place in cinematic history, the Kineorama is still listed in the directory of films made in Japan before the Pacific War, with its own registration number.

25. Quoted in *Benshi: Japanese Silent Film Narrators, and Their Forgotten Narrative Art of Setsumei, a History of Japanese Silent Film Narration*, by Jeffrey A. Dym (Lewiston, N.Y.: Edwin Mellen Press, 2003), 45–46.

Modern and Historical Place-Names

Compiled by the Department of Art of Asia, Oceania, and Africa,
Museum of Fine Arts, Boston

PLACE-NAME USED IN TEXT	JAPANESE	KOREAN	CHINESE POST OFFICE OR OTHER OLDER NAME	CHINESE (WADE-GILES, HYPHENATED STYLE)	CHINESE (PINYIN)	RUSSIAN
Changchun	Chōshun, Shinkyō		Sinking	Ch'ang-ch'un, Hsin-ching	Changchun, Xinjing	
Dalian (Dalny)	Dairen		Dalian	Ta-lien	Dalian	Dalny
Dashiqiao	Taisekikyō		Tashihchiao	Ta-shih-ch'iao	Dashiqiao	
Inch'ŏn (Chemulpo)	Jinsen	Inch'ŏn, Inch'on				
Jiaozhou (Kiaochow)	Kōshū		Kiaochow	Chiao-chou	Jiaozhou	
Jinzhou (Kinchow)	Kinshû		Kinchow	Chin-chou	Jinzhou	
Jiuliancheng (Kiuliencheng)	Kurenjō		Kiuliencheng	Chiu-lien-ch'eng	Jiuliancheng	
Liaodong Peninsula	Ryōtō hantō		Liaotung	Liao-tung pan-tao	Liaodong bandao	
Manchuria	Manshū		Manchuria	Manchou	Manzhou	
Motianling	Matenrei		Motianling	Mo-t'ien-ling	Motianling	
Mukden (Shenyang)	Hōten		Mukden	Shen-yang	Shenyang	
Nampŏ (Chinnampŏ)	Kankō	Nampŏ, Nampo				
Nanshan	Nanzan		Nanshan	Nan-shan	Nanshan	
Pescadores Islands	Hōko shotō		Penghu Islands	P'eng-hu-tao	Penghudao	
Port Arthur (Lüxun)	Ryojun		Port Arthur	Lü-hsun	Lüxun	
P'yŏng'yang (Pingyang)	Heijō	P'yŏng'yang, Pyongyang		P'ing-jang	Pingrang	
Sakhalin Island	Karafuto					Sakhalin
Shandong Peninsula	Santō hantō		Shantung	Shantung pan-tao	Shandong bandao	
Taiwan (Formosa)	Taiwan	Taeman	Taiwan	T'aiwan	Taiwan	
Tsushima	Tsushima	Taemado				
Uiju (Wiju)	Uruju	Uiju				
Weihai (Weihaiwei)	Ikaiei		Weihaiwei	Wei-hai	Weihai	
Yalu River	Ōryokkō	Apnokgang	Yalu River	Ya-lü-chiang	Yalüjiang	

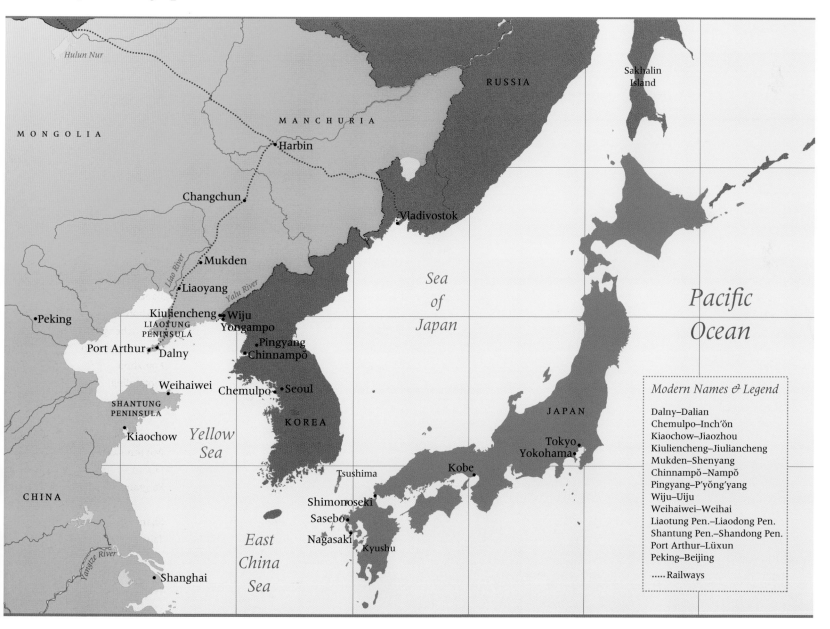

The Seat of War in 1904

MONGOLIA

MANCHURIA

RUSSIA

Sakhalin
Island

Hulun Nur

Harbin

Changchun

Vladivostok

Mukden

Liaoyang

Peking

Kiuliencheng • Wiju
LIAOTUNG Yongampo
PENINSULA
Port Arthur • Dalny Pingyang
 Chinnampŏ

Weihaiwei Chemulpo • Seoul

SHANTUNG
PENINSULA

Kiaochow KOREA

Yellow
Sea

CHINA

East
China
Sea

Shanghai

Sea
of
Japan

Pacific
Ocean

JAPAN

Tokyo
Yokohama

Kobe

Tsushima

Shimonoseki
Sasebo
Nagasaki
Kyushu

Modern Names & Legend

Dalny–Dalian
Chemulpo–Inch'ŏn
Kiaochow–Jiaozhou
Kiuliencheng–Jiuliancheng
Mukden–Shenyang
Chinnampŏ–Nampŏ
Pingyang–P'yŏng'yang
Wiju–Uiju
Weihaiwei–Weihai
Liaotung Pen.–Liaodong Pen.
Shantung Pen.–Shandong Pen.
Port Arthur–Lüxun
Peking–Beijing

.....Railways

85

Color lithograph; ink on card stock
8.8 × 13.8 cm (3⁷/₁₆ × 5⁷/₁₆ in.)
Museum of Fine Arts, Boston, Leonard A. Lauder
Collection of Japanese Postcards, 2002.3728

Page 8
Yoshikuni (active 1904–1905)
Scouts Clash outside the Seven-Star Gate
Japanese, Meiji era, 1904
Woodblock print triptych; ink and color on paper
35.9 × 70.5 cm (14¹/₈ × 27³/₄ in.)
Museum of Fine Arts, Boston, Jean S. and Frederic A.
Sharf Collection, 2000.468

Page 9
Artist unknown
The Life of General Nogi
Japanese, Taishō era, about 1912
Set of eight postcards; color lithograph; ink and metallic
pigments on card stock
Each card: 8 × 13 cm (3¹/₈ × 5¹/₈ in.)
Private collection of Karl Jaeger

Page 10
Clemens Lindpaintner
Shell Coming down 203 Meter Hill
German, about 1904
Gelatin silver print
17.5 × 23 cm (6¹/₈ × 9¹/₁₆ in.)
Private collection of Jean S. and Frederic A. Sharf

Clemens Lindpaintner
Russians on 203 Meter Hill
German, about 1904

Gelatin silver print
18 × 23.2 cm (7¹/₁₆ × 9¹/₈ in.)
Private collection of Jean S. and Frederic A. Sharf

Page 11
Watanabe Nobukazu (1872–1944)
Picture of Our Valorous Military Repulsing the
Russian Cossack Cavalry on the Bank of the Yalu
River
Japanese, Meiji era, March 15, 1904
Woodblock print triptych; ink and color on paper
35.8 x 70.9 cm (14¹/₈ × 27¹⁵/₁₆ in.)
Museum of Fine Arts, Boston, Jean S. and Frederic A.
Sharf Collection, 2000.544

Page 12
Artist unknown
Publisher: Seiundō
Commander of the Manchurian Army
Field Marshal Marquis Ōyama
Japanese, Meiji era, November 1904
Color lithograph on paper
61 × 40.6 cm (24 × 16 in.)
Private collection of Jean S. and Frederic A. Sharf

Page 13
Signed "Guelma"
Interview of Generals Stoessel and Nogi, no. 14 from
the series La Sellette (The Hot Seat)
French, 1905
Lithograph with hand coloring; ink on card stock
8.8 × 13.8 cm (3⁷/₁₆ × 5⁷/₁₆ in.)
Museum of Fine Arts, Boston, Leonard A. Lauder
Collection of Japanese Postcards, 2002.3811

Artist unknown
Publisher: Kyoto Sanjō Benridō
General Kuropatkin Hearing the News of the
Surrender of Port Arthur
Japanese, Meiji era, canceled 1905
Color lithograph; ink on card stock
8.8 × 13.8 cm (3⁷/₁₆ × 5⁷/₁₆ in.)
Museum of Fine Arts, Boston, Leonard A. Lauder
Collection of Japanese Postcards, 2002.5239

Page 14
Kobayashi Kiyochika (1847–1915)
Severe Battle: Occupation of 203 Meter Hill
Japanese, Meiji era, 1905
Woodblock print triptych; ink and color on paper
35.4 × 71 cm (13¹⁵/₁₆ × 27¹⁵/₁₆ in.)
Museum of Fine Arts, Boston, Jean S. and Frederic A.
Sharf Collection, 2000.77

Page 15
Signed "F. Marmonier"
General Kuropatkin, no. 1 from the series
La Cravache
French, 1904–05
Lithograph with hand coloring; ink on card stock
8.8 × 13.8 cm (3⁷/₁₆ × 5⁷/₁₆ in.)
Museum of Fine Arts, Boston, Leonard A. Lauder
Collection of Japanese Postcards, 2002.3790

Signed "Mille"
Kuropatkin Covered with Glory, no. 48 from the series
L'Arc-en-Ciel (Rainbow)
French, 1905
Lithograph with hand coloring; ink on card stock

8.8 × 13.8 cm (3⁷/₁₆ × 5⁷/₁₆ in.)
Museum of Fine Arts, Boston, Leonard A. Lauder
Collection of Japanese Postcards, 2002.3806

Page 16
Artist unknown
Publisher: Shōbidō
The Great Battle of Mukden
Japanese, Meiji era, April 1905
Color lithograph; ink on paper
37.9 × 26.6 cm (14¹⁵/₁₆ × 10¹/₂ in.)
Private collection of Jean S. and Frederic A. Sharf

Page 17
Artist unknown
Publisher: Hōchi shinbunsha
Publisher: Benridō
Printed by: Nakamura Printing Factory (Nakamura Kōjō)
Battle scene from the series Commemorative Postcards of Naval Battles in the Japan Sea
Japanese, Meiji era, 1906
Color lithograph; ink and metallic pigments on card stock
8.8 × 13.8 cm (3⁷/₁₆ × 5⁷/₁₆ in.)
Museum of Fine Arts, Boston, Leonard A. Lauder
Collection of Japanese Postcards, 2002.1574

A. C. Michael (active 1903–1916)
The Cost of Ambition (Mukden)
English, 1905
Pen and black ink with chalk on illustration board
34.3 × 54.6 cm (13¹/₂ × 21¹/₂ in.)
Private collection of Jean S. and Frederic A. Sharf

Page 18
Dudley Hardy (1866–1922)
Publisher: Davidson Brothers
Stuck, *from the series* Pictorial Postcards from

Originals by Dudley Hardy, R.I, Series 3015
English, 1905
Color lithograph; ink on card stock
8.8 × 13.8 cm (3⁷/₁₆ × 5⁷/₁₆ in.)
Museum of Fine Arts, Boston, Leonard A. Lauder
Collection of Japanese Postcards, 2002.3736

Signed "Mille"
Tōgō and Rodzhdestvenskii in the China Seas, *no. 9 from the series* L'Arc-en-Ciel (Rainbow)
French, 1905
Color lithograph; ink on card stock
8.8 × 13.8 cm (3⁷/₁₆ × 5⁷/₁₆ in.)
Museum of Fine Arts, Boston, Leonard A. Lauder
Collection of Japanese Postcards, 2002.3765

Page 19
Signed "Orens"
Roosevelt
French, 1905
Color relief print; ink on card stock
8.8 × 13.8 cm (3⁷/₁₆ × 5⁷/₁₆ in.)
Museum of Fine Arts, Boston, Leonard A. Lauder
Collection of Japanese Postcards, 2002.3760

Signed "T. Bianco"
Roosevelt: Assez!—Enough!—Genug!
French, 1905
Lithograph with hand coloring; ink on card stock
8.8 × 13.8 cm (3⁷/₁₆ × 5⁷/₁₆ in.)
Museum of Fine Arts, Boston, Leonard A. Lauder
Collection of Japanese Postcards, 2002.3761

Page 20
Photographer unknown
The Russian and Japanese Delegations in the Meeting Room, Building 86, Portsmouth Shipyard
American, August 8, 1905
Private collection of Jean S. and Frederic A. Sharf

Page 21
Artist unknown
Publisher: Hakugakkan
Negotiating Peace, Portsmouth, America
Japanese, August 1905
Color lithograph; ink on paper
37.8 × 51.8 cm (14⁷/₈ × 20³/₈ in.)
Private collection of Jean S. and Frederic A. Sharf

Page 22
Artist unknown
Publisher: Kumazawa
Welcoming Ceremony in Tokyo for Admiral Tōgō, Japanese Navy
Japanese, November 1905
Color lithograph; ink on paper
47 × 62.5 cm (18¹/₂ × 24⁵/₈ in.)
Private collection of Jean S. and Frederic A. Sharf

Page 25
George Soper (1870–1942)
The Russian Debacle
English, 1905
Black ink, gouache, graphite, and chalk on illustration board
36.8 × 55.2 cm (14¹/₂ × 21³/₄ in.)
Private collection of Jean S. and Frederic A. Sharf

Page 26
Ernest Prater (active 1885–1937)
Japan at Russia's Throat
English, 1904
Black ink, gouache, graphite, and chalk on illustration board
43.2 × 33 cm (17 × 13 in.)
Private collection of Jean S. and Frederic A. Sharf

Page 27
Frederic De Haenen (active 1896–1920)
End of a Deserter: A Tragedy on the

Trans-Siberian Railway
English, February 11, 1905
Black ink, gouache, and graphite on illustration board
26.7 × 35.9 cm (10¹⁄₂ × 14¹⁄₈ in.)
Private collection of Jean S. and Frederic A. Sharf

Page 29
Albert Edward Jackson (1873–1952)
A Lonely Japanese Vigil, *cover illustration for* Japan's
Fight for Freedom, *volume 45*
English, 1905
Black ink, gouache, graphite, and chalk on
illustration board
30.5 × 29.2 cm (12 × 11¹⁄₂ in.)
Private collection of Jean S. and Frederic A. Sharf

Page 30
James A. Ricalton (1844–1929)
Publisher: Underwood & Underwood
Wrecked Russian Ships Poltava *and* Retvizan *from
Deck of* Peresviet, Port Arthur
American, 1904–05
Stereocard; gelatin silver print on board
17.8 × 8.9 cm (7 × 3¹⁄₂ in.)
Private collection of Jean S. and Frederic A. Sharf

ANNE NISHIMURA MORSE

EXPLOITING A NEW VISUALITY

Page 32
Artist unknown
Robe of the omiyamairi *type with design of the surrender
of General Stoessel to General Nogi*
Japanese, Meiji era, about 1905
Yūzen-dyed silk
109 × 88 cm (42¹⁵⁄₁₆ × 34⁵⁄₈ in.)
Collection of Kozuka Kazuko, Saitama Prefecture

Page 33
Artist unknown
Nagajuban *textile with design of Russo-Japanese War
military leaders (detail)*
Japanese, Meiji era, about 1905
Printed cotton
56 × 35 cm (22¹⁄₁₆ × 13³⁄₄ in.)
Collection of Tanaka Yoku, Tokyo

Page 34
Georges Bigot (1860–1927)
Publisher: Z. T. N. Paris
Empire of Asia
French, 1904–05
Color lithograph; ink on card stock
8.8 × 13.8 cm (3⁷⁄₁₆ × 5⁷⁄₁₆ in.)
*Museum of Fine Arts, Boston, Leonard A. Lauder
Collection of Japanese Postcards, 2002.3727*

Page 36
Toyohara Chikanobu (1838–1912)
Illustration of the Rebels Being Suppressed at
Kagoshima
Japanese, Meiji era, October 4, 1877
Woodblock print triptych; ink and color on paper
37 × 74.9 cm (14⁹⁄₁₆ × 29¹⁄₂ in.)
*Museum of Fine Arts, Boston, Jean S. and Frederic A.
Sharf Collection, 2000.488*

Page 38
Asai Chū (1856–1907)
Captain Higuchi Rescuing a Child
Japanese, Meiji era, 1895
Oil on canvas
74.5 × 101.5 cm (29⁵⁄₁₆ × 39¹⁵⁄₁₆ in.)
*Museum of the Imperial Collections (Sannomaru
Shōzōkan), Imperial Household Agency*

Asai Chū (1856–1907)
Searching after the Combat in Port Arthur
Japanese, Meiji era, 1895
Oil on canvas
124.5 × 88 cm (49 × 34⁵⁄₈ in.)
Tokyo National Museum

Page 39
Kuroda Seiki (1866–1924)
Informal Views of the Japanese Troops in China
Japanese, Meiji era, November 25, 1894
Ink and light color on paper
12.3 × 18.2 cm (4¹³⁄₁₆ × 7³⁄₁₆ in.)
National Research Institute for Cultural Properties, Tokyo

Page 40
*"Life on board a Man-of-War, Practice with a Six-Inch
Breech-Loading Gun:'A Hit!'" from the* Illustrated
London News, *May 18, 1889*

Mizuno Toshikata (1866–1908)
Japanese Warships Fire on the Enemy near Haiyang
Island
Japanese, Meiji era, 1894
Woodblock print triptych; ink and color on paper
35.5 × 72.3 cm (14 × 28⁷⁄₁₆ in.)
*Museum of Fine Arts, Boston, Jean S. and Frederic A.
Sharf Collection, 2000.380.13*

Page 41
Kubota Beisen (1852–1906)
Kubota Beisai (1874–1937)
Kubota Kinsen (1875–1954)
Publisher: Okura Yasugorō
Illustrated Record of the Battles of the Sino-
Japanese War
Japanese, Meiji era, 1894–95

Woodblock printed book; ink and color on paper
Each page 17.4 × 23.8 cm (6⅞ × 9⅜ in.)
Museum of Fine Arts, Boston, Jean S. and Frederic A.
Sharf Collection, 2000.338

Page 42
Kobayashi Kiyochika (1847–1915)
A Soldiers's Dream at Camp during a Truce in the
Sino-Japanese War
Japanese, Meiji era, April 1895
Woodblock print triptych; ink and color on paper
37.2 × 75.1 cm (14⅝ × 29⁹⁄₁₆ in.)
Museum of Fine Arts, Boston, Jean S. and Frederic A.
Sharf Collection, 2000.279

Page 43
"How Japanese War Pictures Are Made," from the
Illustrated London News, December 29, 1894

Page 44
Signed "Toshimitsu"
After the Battle: Kindness to the Fallen Foe
Japanese, about 1904
Black ink, watercolor, graphite, and chalk on paper
55.9 × 40.6 cm (22 × 16 in.)
Private collection of Jean S. and Frederic A. Sharf

Utagawa Kokunimasa (Ryūa, dates unknown)
Russo-Japanese War: Great Japan Red Cross
Battlefield Hospital Treating the Injured
Japanese, Meiji era, March 1904
Woodblock print triptych; ink and color on paper
37.3 × 72 cm (14¹¹⁄₁₆ × 28⅜ in.)
Museum of Fine Arts, Boston, Jean S. and Frederic A.
Sharf Collection, 2000.367

Page 45
Artist unknown
Nurse and Soldiers
Japanese, Meiji era, 1906
Color lithograph; ink on card stock
8.8 × 13.8 cm (3⁷⁄₁₆ × 5⁷⁄₁₆ in.)
Museum of Fine Arts, Boston, Leonard A. Lauder
Collection of Japanese Postcards, 2002.3597

Artist unknown
Nurse Holding a Cherry Blossom Branch
Japanese, Meiji era, about 1904–05
Color lithograph; ink and metallic pigment on card stock
8.8 × 13.8 cm (3⁷⁄₁₆ × 5⁷⁄₁₆ in.)
Museum of Fine Arts, Boston, Leonard A. Lauder
Collection of Japanese Postcards, 2002.3593

Artist unknown
Nurse and Lily
Japanese, Meiji era, canceled 1905
Color lithograph; ink and metallic pigment on card stock
13.8 × 8.8 cm (5⁷⁄₁₆ × 3⁷⁄₁₆ in.)
Museum of Fine Arts, Boston, Museum purchase with
funds donated by Leonard A. Lauder, 2003.507

Page 46
Front page of the Illustrated London News,
March 19, 1904

Page 47
Kōkyo (active 1877–1904)
Illustration of Our Destroyers Hayatori and Asagiri
Sinking Enemy Ships at Port Arthur during a Great
Snowstorm at 3:00 a.m. on February 14, 1904
Japanese, Meiji era, February 1904

Woodblock print triptych; ink and color on paper
34.7 × 69.1 cm (13¹¹⁄₁₆ × 27³⁄₁₆ in.)
Museum of Fine Arts, Boston, Jean S. and Frederic A.
Sharf Collection, 2000.543

Page 48
Getsuzō (active 1904–1905)
A Fight at the Yalu River
Japanese, Meiji era, June 1, 1904
Woodblock print triptych; ink and color on paper
35.5 × 69.5 cm (14 × 27⅜ in.)
Museum of Fine Arts, Boston, Jean S. and Frederic A.
Sharf Collection, 2000.447

Page 49
Getsuzō (active 1904–1905)
By Destroying the Enemy Wire Entanglements
[Japanese Forces] Capture the Enemy Fortress at
Nanshan
Japanese, Meiji era, printed September 20, 1904
Woodblock print triptych; ink and color on paper
35.4 × 70.1 cm (13¹⁵⁄₁₆ × 27⅝ in.)
Museum of Fine Arts, Boston, Jean S. and Frederic A.
Sharf Collection, 2000.449.1–3

Page 50
Artist unknown
Publisher: Haibara
Picture Postcards Commemorating the Battle of the
Japan Sea
Japanese, Meiji era, 1905
Set of postcards; color lithograph; ink on card stock
13.8 × 8.8 cm (5⁷⁄₁₆ × 3⁷⁄₁₆ in.)
Museum of Fine Arts, Boston, Leonard A. Lauder
Collection of Japanese Postcards, 2004.474-8

Page 69
Seki Shigetada (1863–1945)
The Main Battleship Squadron Blockading Port
Arthur in Stormy Weather
Published by K. Ogawa in The Russo-Japanese War:
Naval, *no. 1 (1904)*
Private collection of Jean S. and Frederic A. Sharf

Ichioka Tajirō (dates unknown)
Firing a Six-Inch Quick-Firing Gun
Published by K. Ogawa in The Russo-Japanese War:
Naval, *no. 1 (1904)*
Private collection of Jean S. and Frederic A. Sharf

Ichioka Tajirō (dates unknown)
Firing a Nordenfeldt Machine Gun
Published by K. Ogawa in The Russo-Japanese War:
Naval, *no. 1 (1904)*
Private collection of Jean S. and Frederic A. Sharf

Page 70
Postcard artist unknown
Original photograph by an unidentified photographer of
the Mitsumura Toshimo Photographic Unit
Publisher: Ogawa Isshin (1860–1929)
Memorable Meeting of Generals Nogi and Stoessel
after the Fall of Port Arthur at Shuishiying
Photographed after Luncheon on January 5, 1905
Japanese, Meiji era, 1905
Collotype; ink on card stock
8.8 × 13.8 cm (3⁷/16 × 5⁷/16 in.)
Museum of Fine Arts, Boston, Leonard A. Lauder
Collection of Japanese Postcards, 2002.3892

Unidentified photographer of the Mitsumura Toshimo
Photographic Unit
Generals Stoessel and Nogi
Japanese, taken January 5, printed after
January 27, 1905
Gelatin silver print
26.2 × 33.1 cm (10⁵/16 × 13¹/16 in.)
Private collection of Jean S. and Frederic A. Sharf

Page 73
Artist unknown
Cover for Nichirō sensō shashin gahō *(The Russo-*
Japanese War Photographic Pictorial)
Japanese, Meiji era, October 15, 1904
Color lithography on paper
26 × 18.4 cm (10¹/4 × 7¹/4 in.)
Private collection of Jean S. and Frederic A. Sharf

Page 76
Photographer unknown
Members of the Yoshizawa Shōten Cinematographic
Unit, Shortly after Their Capture during the Battle of
Liaoyang, 1904, *from an album of photogravures*
Russian, published about 1906
Private collection of Jean S. and Frederic A. Sharf